# CHARD AND ITS VILLAGES

## THROUGH TIME

Frank Huddy *&* Jeff Farley

AMBERLEY PUBLISHING

# Acknowledgements

Most photographs, past and present, are by Jeff Farley, assisted by his wife Julie. The text (including mistakes!) is by Frank Huddy, with much help from his wife Jean. We are also grateful to Dave Wheadon, John Gibson, Alan Brown and John White for their help and advice, and, of course, to the staff at Amberley Publishing, especially Sarah Flight.

First published 2010

Amberley Publishing
Cirencester Road, Chalford,
Stroud, Gloucestershire GL6 8PE

www.amberleybooks.com

Copyright © Frank Huddy & Jeff Farley, 2010

The right of Frank Huddy & Jeff Farley to be identified as the Authors of this work has been asserted in accordance with the Copyrights, Designs and Patents Act 1988.

ISBN 978-1-4456-0035-2

British Library Cataloguing in Publication Data.

A catalogue record for this book is available from the British Library.

Typeset in 9.5pt on 12pt Celeste.
Typesetting by Amberley Publishing.
Printed in the UK.

# Introduction

Chard's history goes back to before the arrival of the Romans; whose presence left behind plenty of evidence. Mentioned in the *Domesday Book*, the town became a borough in 1234; 200 years later it was important enough to send representatives to Parliament. This was a mixed and expensive blessing. By the sixteenth century, Chard was growing rapidly and becoming a busy weaving town, but the trade shrank rapidly and by the early 1800s it had all but vanished, to be replaced for many years by the lace trade and other industries. Engineers, iron founders, clockmakers, printers, brewers and many other tradesmen flourished in Chard. It was one of the most industrialised small towns in the country for some years. Clay pipes, pencils, gloves and artificial limbs were produced here, but Chard is famous all over the world as 'the birthplace of powered flight' and its museum, an award-winning entity, is constantly receiving visitors from overseas who are researching John Stringfellow's momentous invention. Still industrialised, although not to the same degree, Chard today is full of history and, for some, mystery too.

The Choughs Hotel in the High Street is reputedly one of the most haunted buildings in England and has received visits by 'ghostbusters' including a TV team who spent a night in the hotel but failed to find a ghost. Mysterious noises were heard, just as they have been in other buildings, including the museum, part of which was a public house for many years.

Chardstock village has its ghosts, one of whom I have experience of, although I didn't see it. A horse and carriage has reputedly been seen at 'Galloping Close' in the lanes from Chardstock to Chard, but only at midnight on certain dates. I knew a couple of old-timers who claimed to have seen it but it's not clear whether or not they had just left the George Inn, also reputed to have a ghost or two. Unfortunately, no photographs exist of the many sightings around Chard and district.

Apart from the Choughs, one seldom hears ghost tales these days, but of course there are far less pubs to stagger from...

Chard is the highest town in Somerset and receives more than its share of rainfall, but the views from its hills more than compensate for this and all its villages have a charm of their own – quaint side streets little altered for over a century, striking views over rolling hills and valleys, and churches standing like proud forts, as they have for hundreds of years. The pages and photographs in this book will take the reader on a journey through town and countryside and will evoke memories of days gone by and, perhaps, visions of years yet to come.

Apart from John Stringfellow, other famous Chardians include Margaret Bonfield MP, England's first female cabinet minister, James Gillingham, the pioneer of artificial limbs, and Cpl Sam Vickery, who was born in Wambrook in 1873 and won the VC for bravery in the 1897 Tirah Campaign. He rescued a wounded comrade under heavy fire, killed two of the enemy and was himself wounded. He fought in the Boer War and the First World War and retired as a sergeant, having won seven medals with nine bars. Despite his hectic life he lived on until 1952.

The Chard I knew as a young man bears little resemblance to the Chard of today. It was a much smaller place in my youth and we knew almost all the residents, yet it bustled with activity by day and night – two cinemas, many more pubs, dances at the Guildhall (then the Corn Exchange). The streets were always full of pedestrians, shopping by day and 'on the town' at night. With all this activity there was little trouble apart from the odd punch-up at closing time, but real policemen patrolled the streets by day and night. The shopkeepers were friendly and polite and you got served – unlike today. Now my town is full of soulless supermarkets and you can't buy half the things you need without going to a bigger town. It's not safe to walk the streets late at night and your doors have to be securely locked at all times. Old-timers will tell you, 'Chard isn't the place it used to be.' Sadly, they are right – but for me it will always be the place to come home to.

Frank Huddy
October 2010

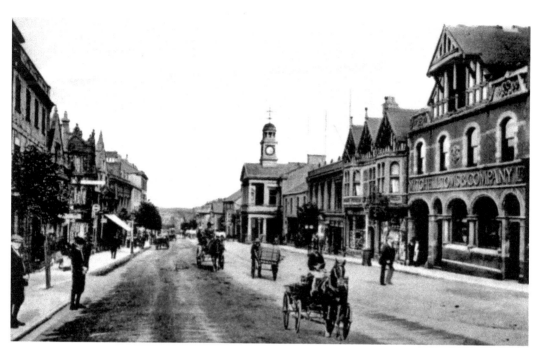

**Fore Street (I)**

In 1906 the street had a much more impressive façade on the Guildhall side. It is now simply a row of small shops, perhaps more varied than a century ago but certainly far less appealing to the eye. Sadly, this is true of many towns, largely a result of planning vandalism, especially that of the 1970s.

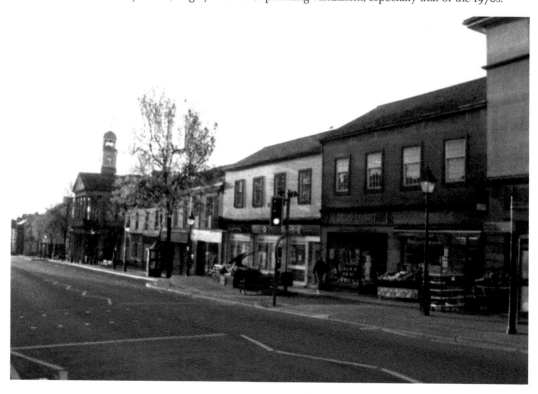

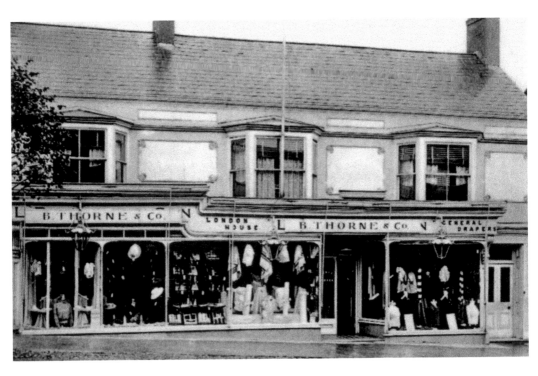

Thorn & Co.
Once one of Chard's largest retailers, Thorn & Co. boasted splendid premises that have been occupied for many years by the Chard Conservative Club. Just outside the town centre, the shop was a Mecca for ladies and gentlemen of good taste.

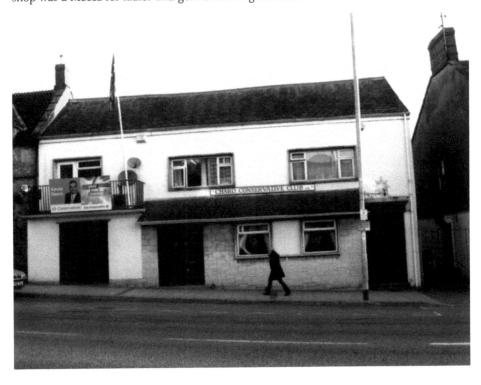

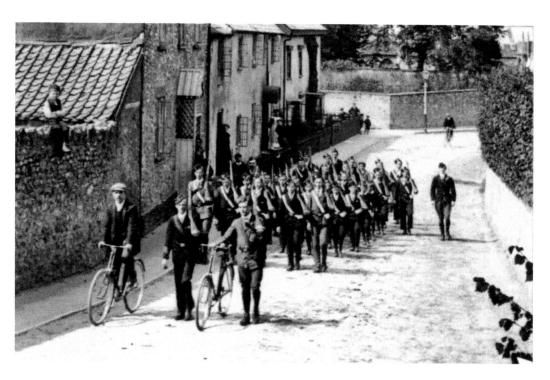

## Tatworth Road

These vividly contrasting shots were taken from exactly the same spot over eighty years apart. The cadets appear to be carrying real rifles and one of the cyclists is working very hard pushing his machine with his right hand, since his left is laden with a rifle.

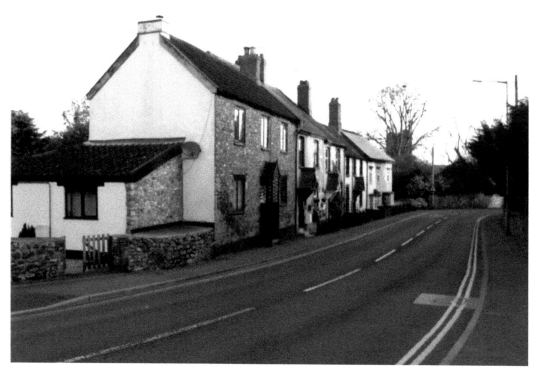

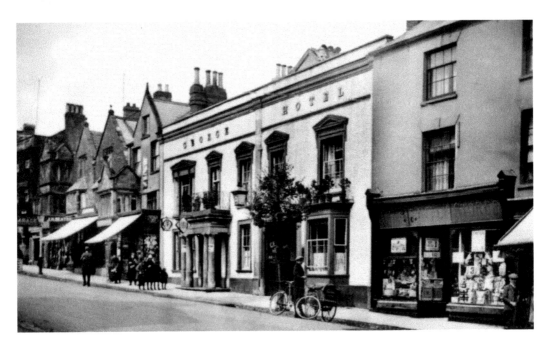

### The George

Perhaps Chard's leading hostelry, right opposite the Guildhall sits the George. The building was hit by a disastrous fire in the 1990s. Rising from the ashes, it was appropriately renamed the Phoenix and it is once again a favourite with locals and visitors alike.

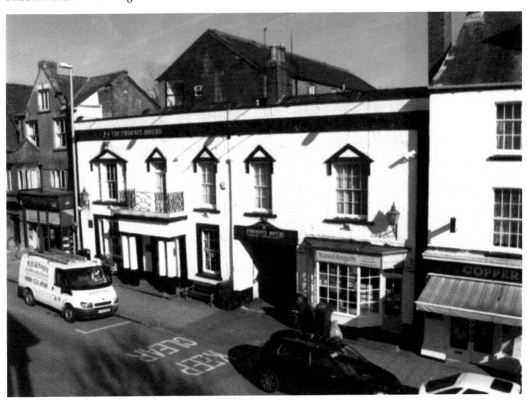

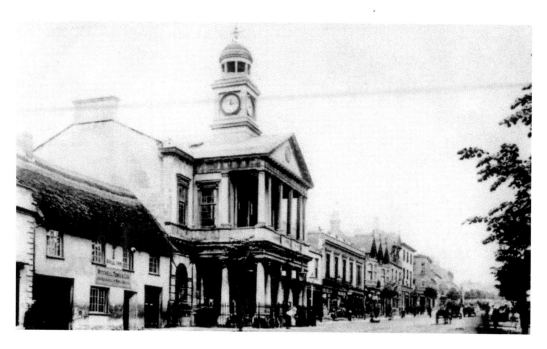

## The Guildhall

On the other side of Fore Street, what was once known as the Corn Exchange retains its impressive façade. The delightful old Ball Inn was attacked by the building vandals of the 1970s and replaced by a hideous lump of concrete, which is now occupied by the excellent Store 21.

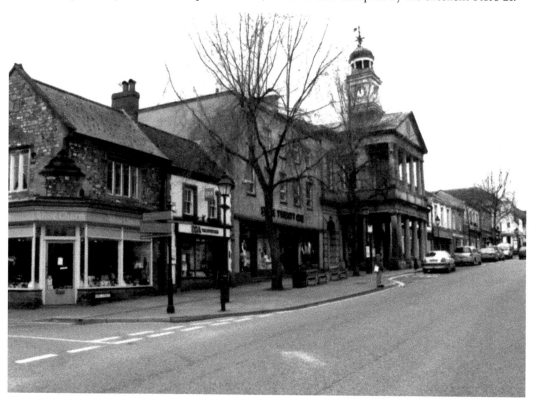

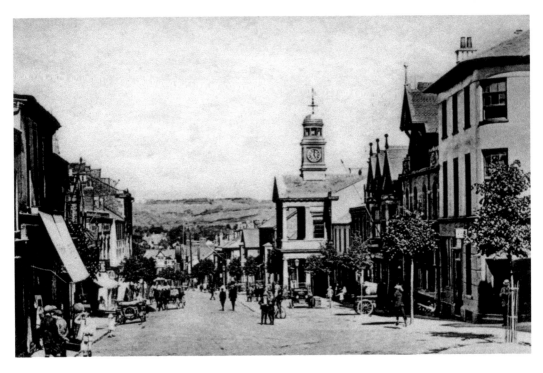

## Fore Street (II)

Cars and horse-drawn traffic can be seen in this 1920s photograph of Fore Street, which has altered little in the eighty or so years separating the pictures. In fact, the lady with the shopping trolley seems to be in no more danger that the folk standing in the middle of the street so many years earlier.

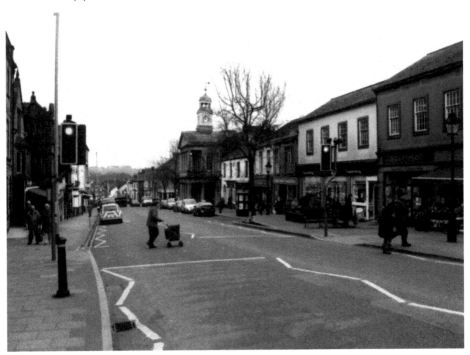

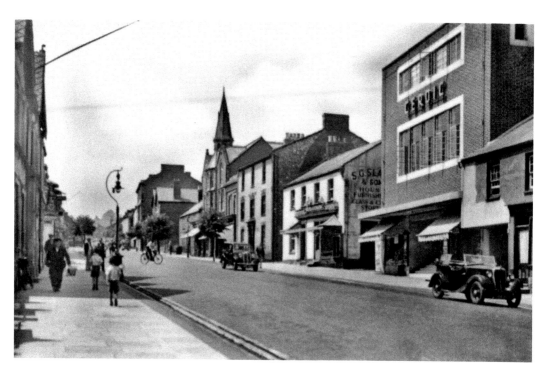

## The Cerdic Cinema

Famous for its rows of double seats at the rear of the balcony, the Cerdic Cinema was a hotbed of romance from the '30s to the '70s. It is still going strong today as a Wetherspoons and it's good to see that the new company has retained the old name. The double seats are gone, but not the memories.

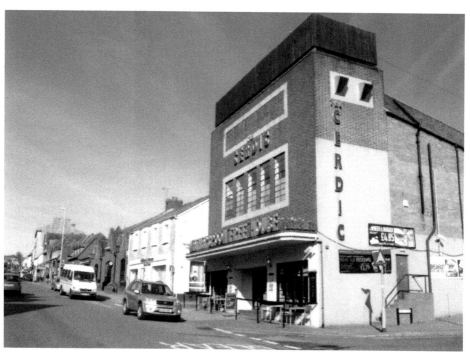

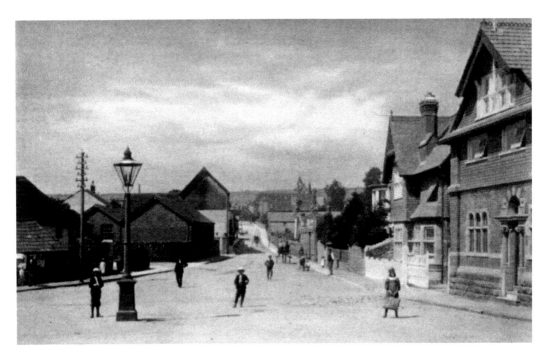

## East Street (I)

The bottom of East Street in around 1890 almost completely lacked traffic. It is now one of the busiest areas of the town. A roundabout has replaced the central street lamp and the house on the right, now Jewsons, still stands, as do two buildings further up the street. On the left is the old wool store, a relic of Chard's once-prosperous past. Sadly, it is now derelict.

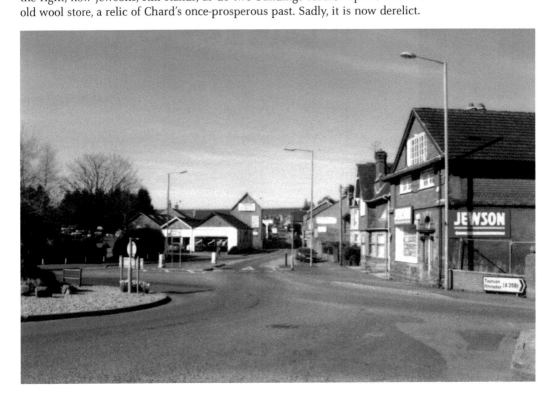

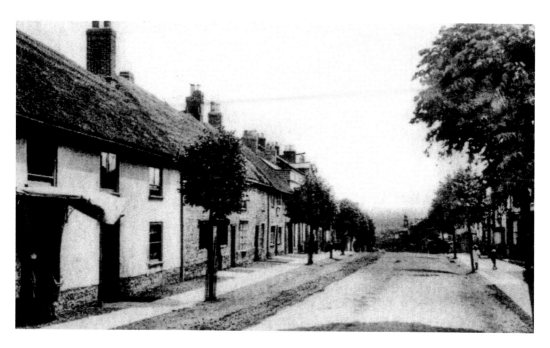

### The High Street (I)

There are 110 years between these two shots of the High Street from the top end of town. The front of the houses has changed little, but in 1900 a public house stood on the left going down the hill. It is still there, but it now houses the famous Chard Museum, one of the finest small town museums in the UK, here shown with its glorious red cherry tree in full bloom.

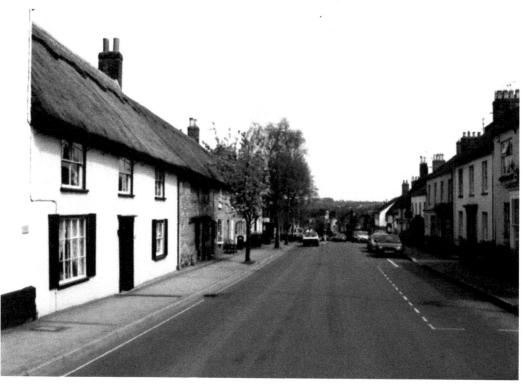

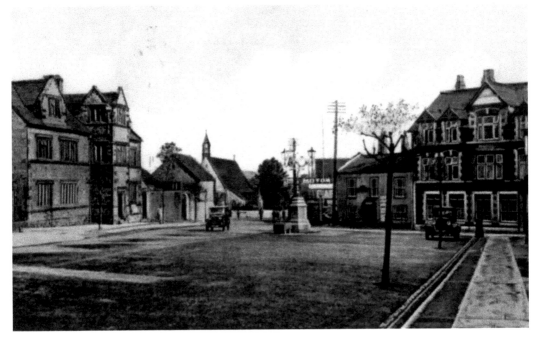

## Chard School

Little has changed at Chard School and the Red House between 1920 and 2010. A feature of Chard is its broad main street, over half a mile long. Even today, it can afford parking spaces on both sides, despite the massive increase in through traffic.

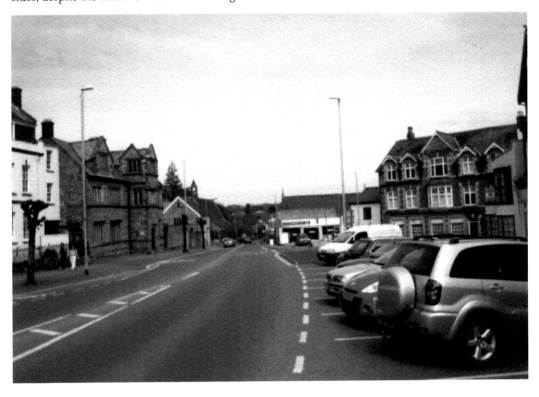

## Hughes & Co.

Yet another of Chard's drapers and milliners, Hughes & Co. was established in around 1870 and by the 1890s Chard boasted a dozen or so similar establishments, along with an assortment of menswear shops. Since Hughes' day, the best-remembered incumbents were Gill's bakery and café, for years *the* place to take your lady for afternoon tea. After a spell as an employment exchange, the twenty-first century has seen its return to the catering profession with the opening of the Café au Lait. The surrounding buildings have changed little since the Hughes era.

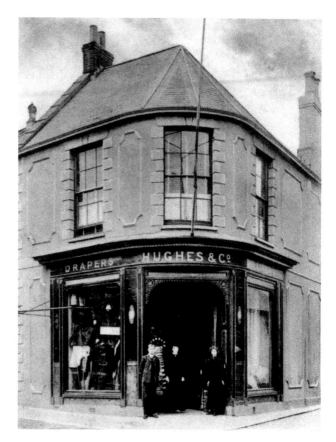

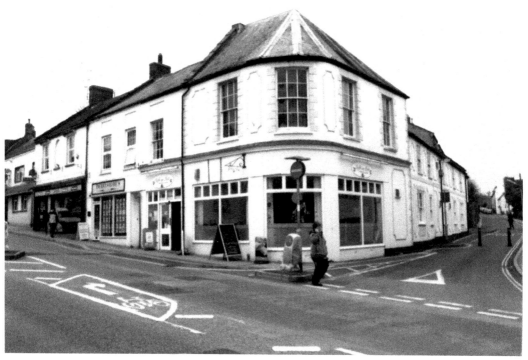

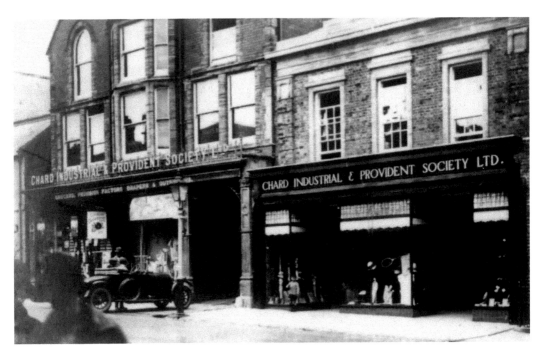

Chard Industrial and Provident Society

This superb shop sold everything from groceries to clothing and more. Although the building was replaced by new premises some years ago, it is still the Co-operative, although it carries a much reduced stock.

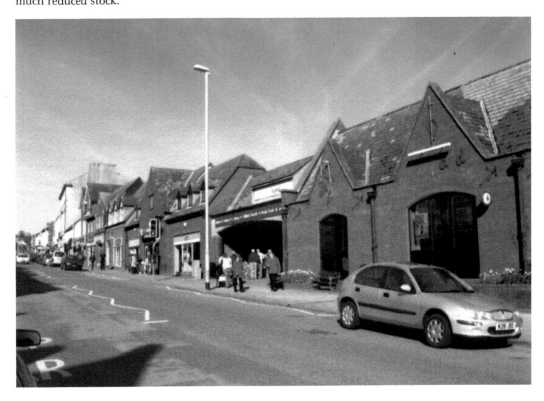

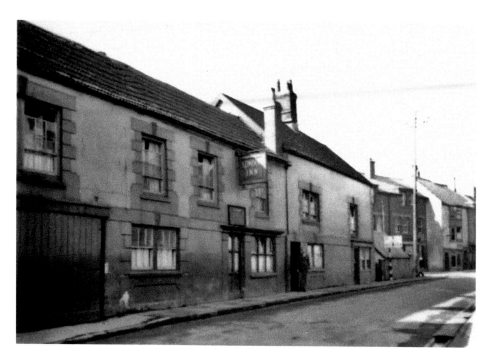

## Holyrood Street (I)

This is one of the less photographed areas of Chard and the 1920s shot perhaps shows why. The old London Inn and Mrs Brown's greengrocery are long gone, replaced by new shops and the large Sainsbury's superstore. The buildings in the background, mostly small shops, are much as they were eighty years ago.

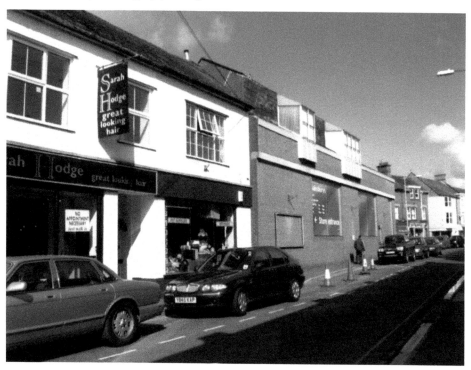

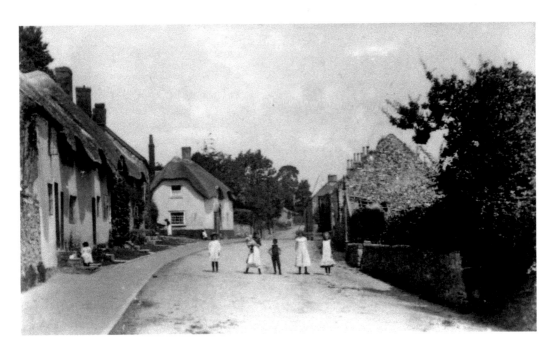

## Crimchard

The road to Wadeford has changed little over the last 120 years. In the late 1800s the thatched white cottage on the left stood out and its demolition in around 1910 made ways for workshops that are in full swing today. The wide pavement on the left has been tramped on by many thousands of feet and is still doing good service, although it now stretches much further along the road, to Wadeford and Combe.

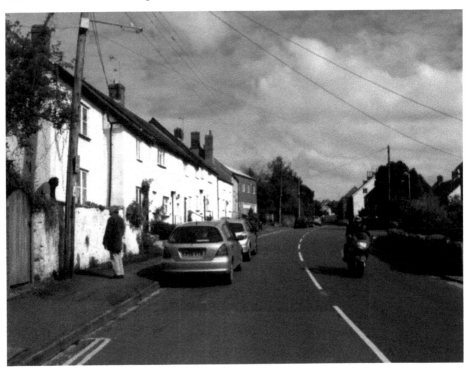

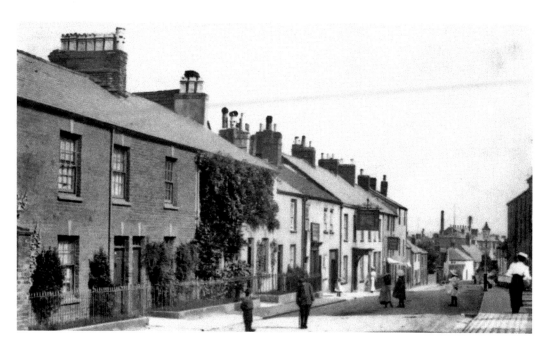

## Combe Street

Another little-photographed area of Chard is seen here in around 1910. The two pubs on the left were side by side; older residents will remember staggering from the White Hart to the Royal Oak or vice versa. Both pubs closed in the 1960s. Further down the road can be seen the chimneys of the two factories in Boden Street, Gifford Fox and Bodens, neither now fulfilling their original functions. Opposite the pubs for many years was the pencil factory of L. & C. Hardtmuth, replaced some forty or so years ago by flats.

## Park Terrace

At the top of Crimchard stands the superb Park Terrace, originally known simply as Park, which was built in the early 1900s for workers at the factories. They must have thought they had moved to Shangri-La after experiencing what were near-slums. Standing proud, with an outlook to the hills beyond, the terrace is a fine sight today.

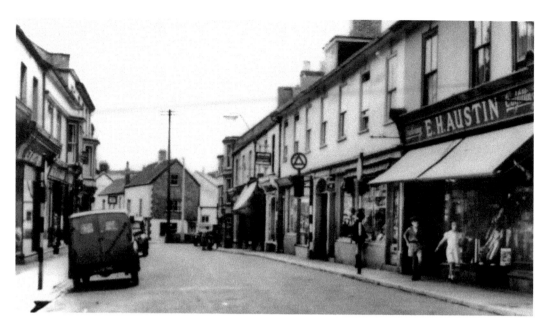

## Holyrood Street (II)

Many changes have taken place in the fifty years between these two photographs. At the far end the long-gone London Inn and adjacent fruit and veg shop have been replaced by a spanking modern Sainsbury's store. The street itself has become one-way, Austin's famous shops (on both sides of the street) have disappeared, and almost all the small shops have changed ownership. Progress? I'm not so sure.

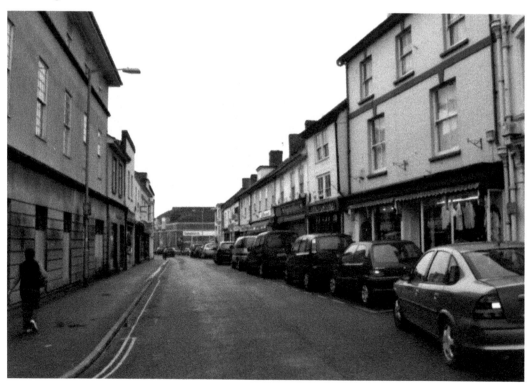

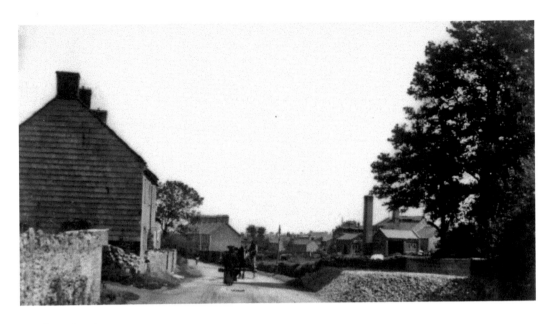

## Furnham Road

This part of the road was not often photographed. The early shot shows what appears to be a lady about to collide with a horse and cart in the middle of the road. Hopefully they both missed! On the right is the old gasworks, now replaced with modern housing. Note the small house on the left of the new photograph, added to what is still Norns Terrace. Furnham Road is on the main thoroughfare from Taunton to Axminster and is rarely seen with so little traffic.

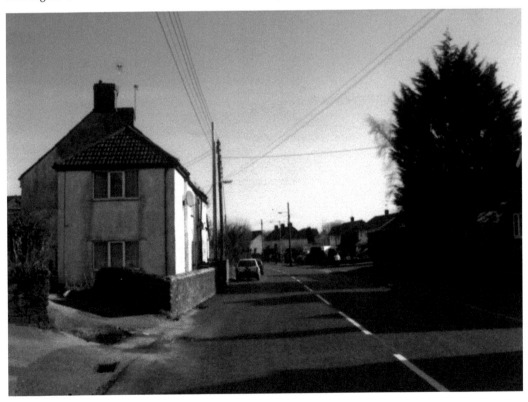

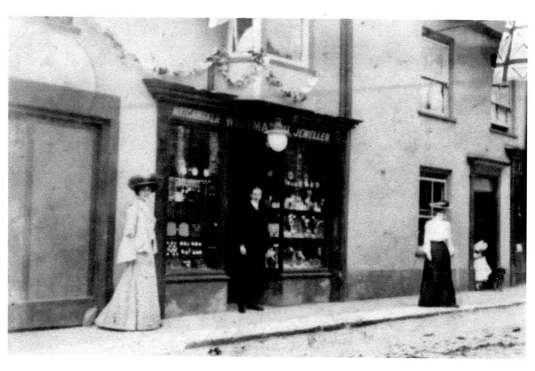

### East Street (II)

This very rare 1890s picture shows the shop of jeweller Mr Whitmarsh in lower East Street. As today's photograph shows, the shop was quite near the old Railway Hotel, which is still very much in business as The Happy Return.

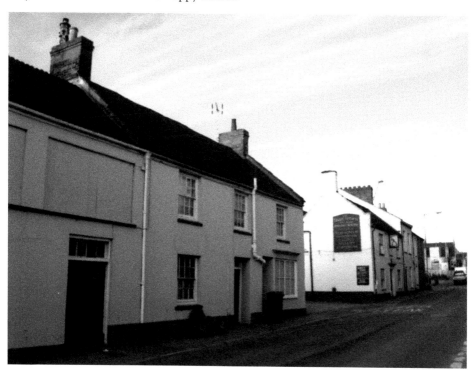

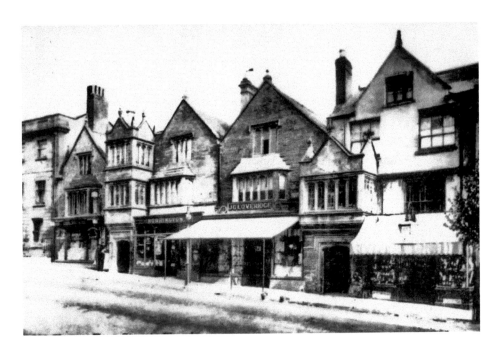

Fore Street

Behind ancient frontage, still not so different today, is the courtroom in which the infamous
Judge Jeffries is said to have passed sentence on several rebels who were then hanged from
a tree at the bottom of Chard for their support of the Monmouth Rebellion. Chard Museum
hosts a small piece of wood said to be from the tree. At the top of the modern row of shop
fronts stands NatWest Bank, for many years the important Crown Hotel.

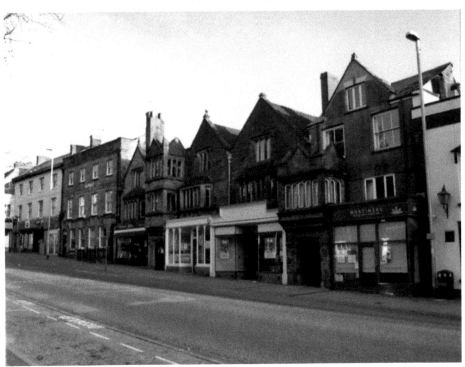

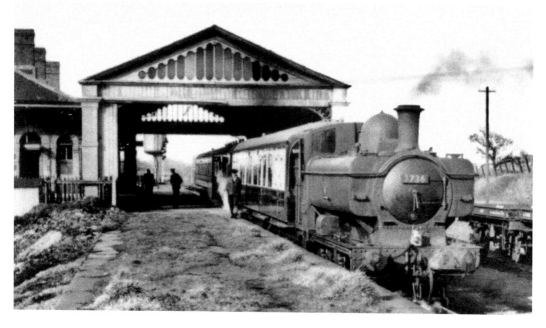

## Chard Station
Chard lies on the branch line from Taunton to Chard Junction. The station is seen here in the late 1950s with the 'Chard Snail' on the way to the main line. Some forty years later it is derelict, definitely not a pretty sight. There is, however, news of it being taken over by a national retail company who intend to restore its former glory.

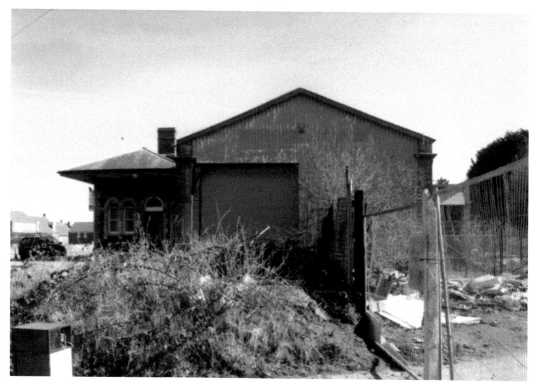

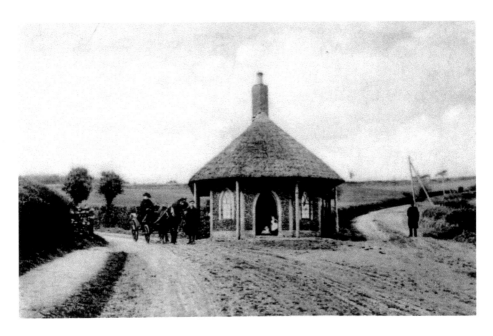

## Snowden Gatehouse

Probably Chard's most photographed building, the old Snowden gatehouse on the A30 to Honiton has a splendid view of the town and district. It was enjoyed for seventy-five years by Nora Jewel (inset), who was born there and spent a lifetime with no electricity or gas and drew her water from a well across the road. This 2010 photograph shows the house looking much the same as in 1885. It is now used as a novel holiday home. The daffodils in the 2010 photograph are now a feature of each main road into Chard.

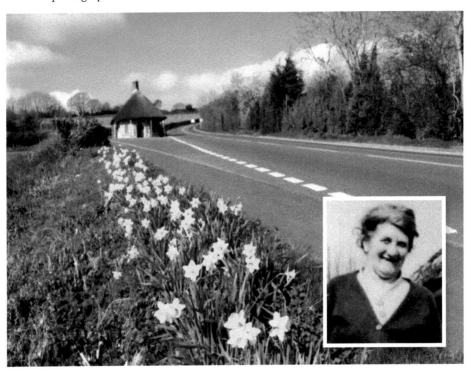

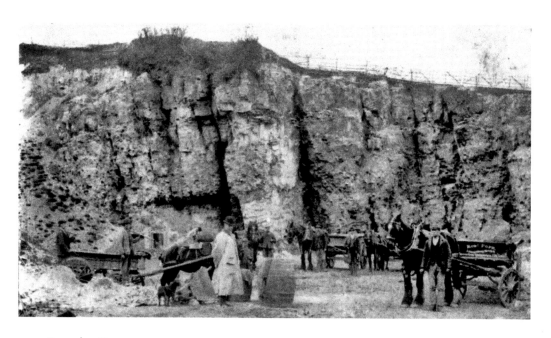

Snowden Quarry

Across the main road from the gatehouse, stone was dug in large quantities until the early 1900s. Many of Chard's older houses are built of Snowden stone. Overgrown and abandoned, the quarry is now a wildlife sanctuary and a lovely, peaceful spot.

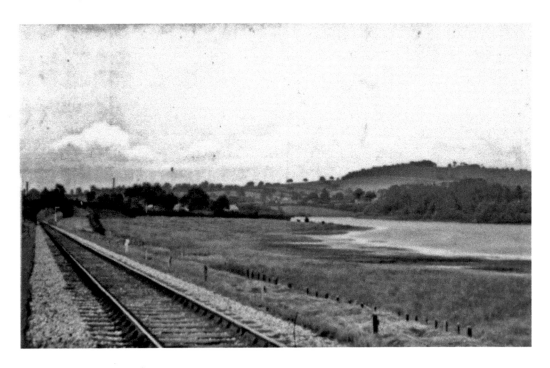

### The Chard-Taunton Railway

Almost unrecognisable today, the track is now an excellent cycleway that still runs alongside what was the reservoir for the Chard-Taunton canal, opened in 1834. Behind the trees on the right-hand side of 2010 photograph lies what is now the well-known Chard Nature Reserve, famous for its wildlife. Many birds visit this spot from overseas.

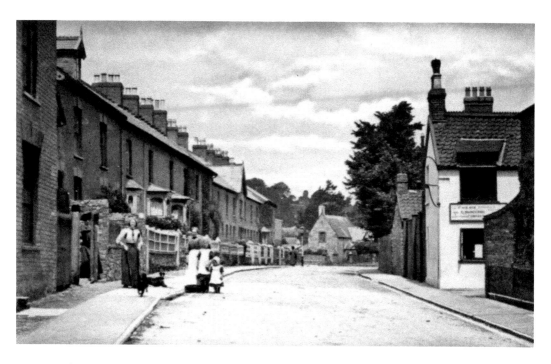

### Combe Street

The upper end of Combe Street in around 1905 shows Rose Terrace with the fledgling Phoenix Engineering works opposite. Over a hundred years later, Phoenix is still in full production, sending goods all over the world from much-changed premises.

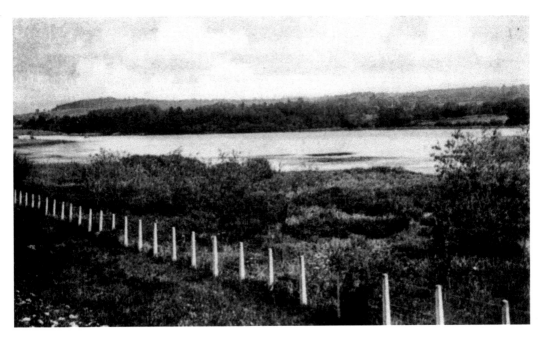

## Chard Reservoir

The first shot, taken in around 1900 from the railway, shows little tree growth. The modern photograph, with fishermen and seabirds on the alert, gives a fair idea of the reservoir's use today.

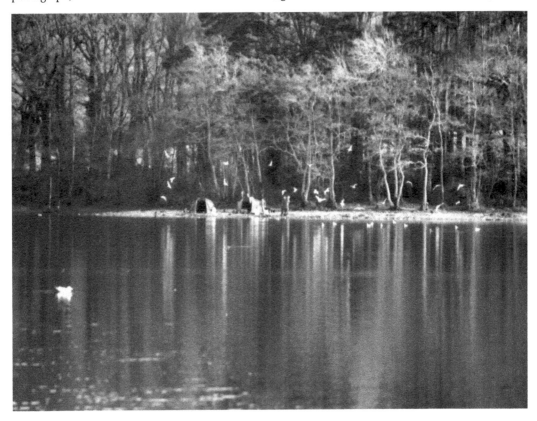

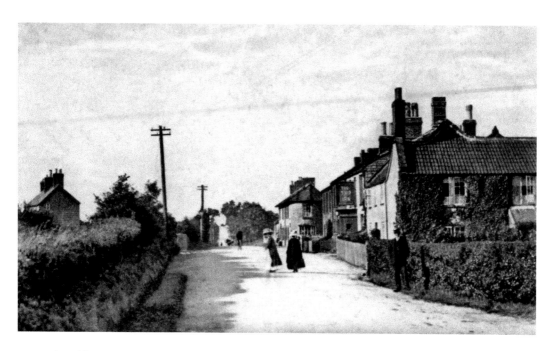

## The Ship Inn

On what is now the A358 leading out of Chard towards Ilminster, over a hundred years ago the Ship Inn welcomed visitors entering or leaving town. It still does, but several of its adjoining cottages have vanished to make way for a new road. On the opposite side of the road for many years stood Carpenters Stores, which is now a private dwelling, but the Ship sails serenely on.

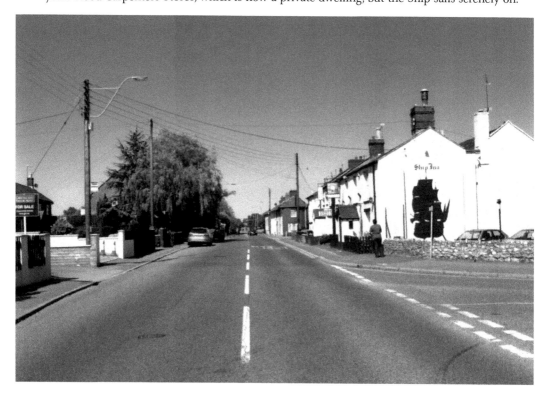

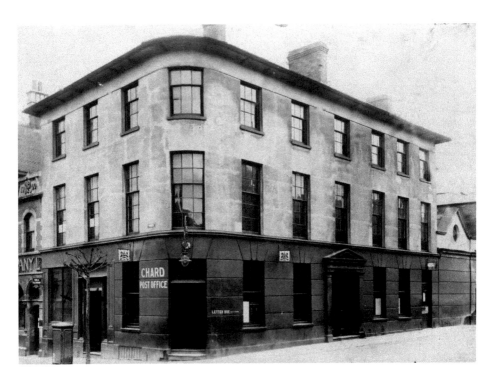

### Chard Post Office
Still standing on the corner of Holyrood Street and Fore Street, this grand old building was built in around 1800 as a private house and for over half of the twentieth century it was a bustling post and sorting office. Shops and offices have replaced it.

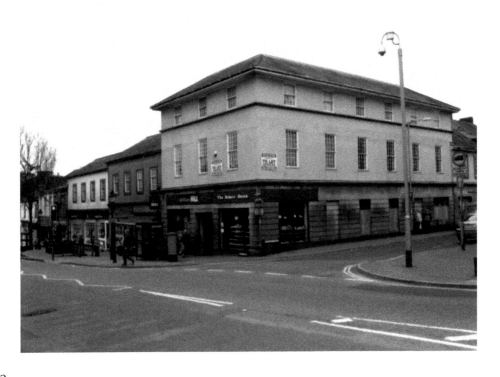

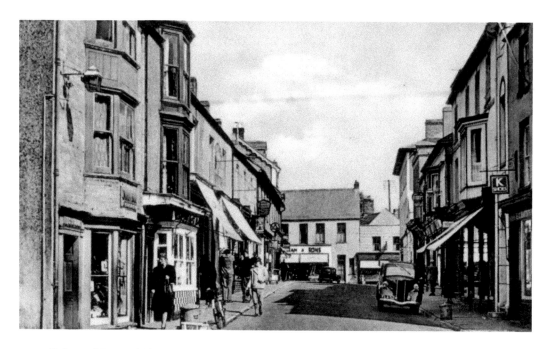

## Holyrood Street (III)

Almost all the shops have changed since the late 1940s, yet the buildings remain the same. In the early picture Tommy Squire's cycle shop (on the left) is directly opposite Batstone's shoe emporium. The only shop remaining from some sixty years later is the butcher's next to Squire's – under different ownership, of course. At the far end, Parham & Sons, general drapers, are sadly gone, but for many years it was a shoppers' favourite and their seasonal sales were legendary.

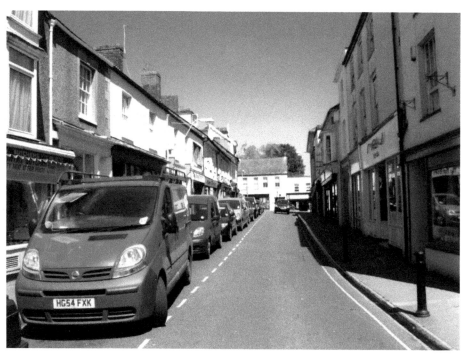

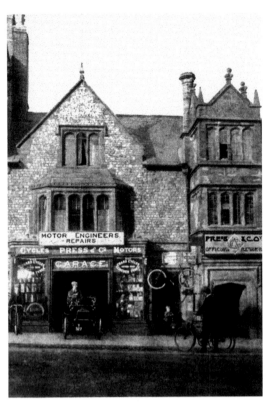

**Press & Co.**
Judge Jeffries' courthouse still lurks behind the shop fronts and this rare photograph of Press & Co.'s garage, taken around a hundred years ago, shows a wide variety of transport. The small car has solid tyres, carbide lamps and the number Y327. The little boy proudly displays his vehicle and the two men have a bicycle and a tricycle respectively. The 2010 shot is much more attractive, although the façade is basically unchanged.

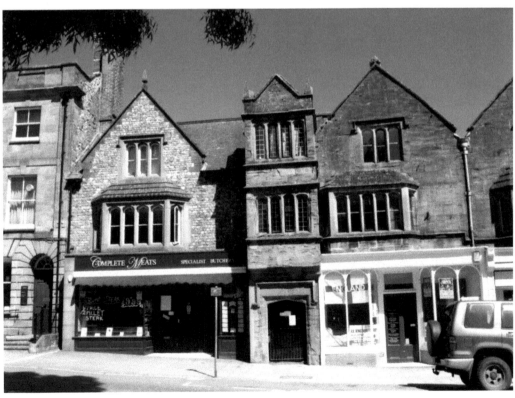

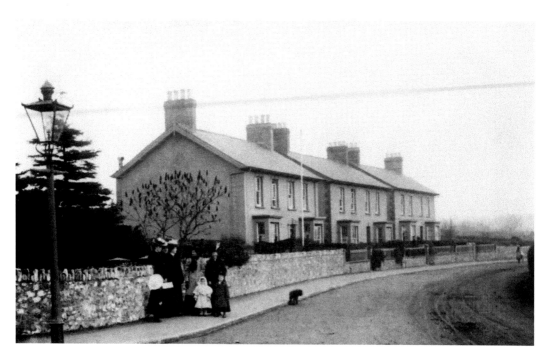

## Crewkerne Road

A very rare photograph shows the villas soon after completion. Postmarked '1903', these robust houses look as good as new today. The spare piece of land where the family stood over a hundred years ago was once a garage and is now an ATS depot.

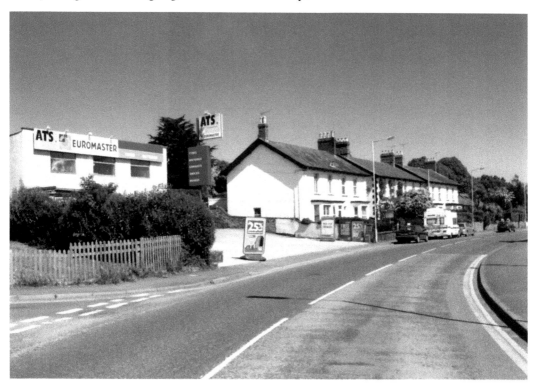

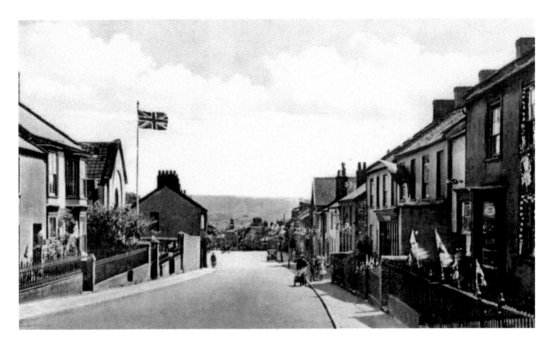

**High Street School**

This early photograph is the only one I've ever seen of High Street School proudly flying its flag. Many of my friends were pupils here and can remember running across the road to Miss Gillard's tiny sweetshop, now long gone. The school is replaced by Helliers Road, now a busy thoroughfare taking traffic to Combe St Nicholas and beyond.

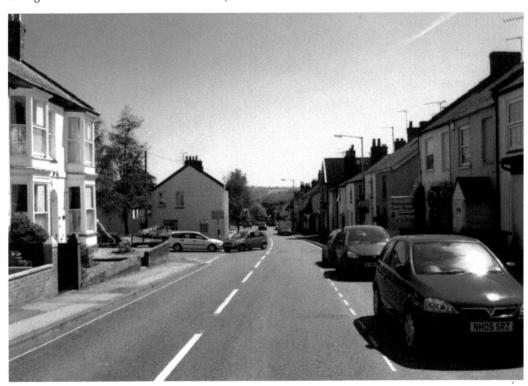

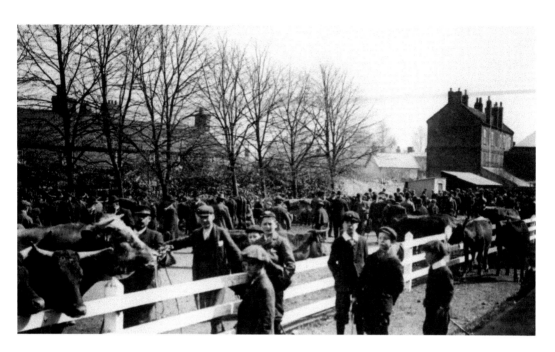

## Chard Cattle Market

Only old-timers like me will remember Chard's regular cattle market, which this 1907 photograph shows in full swing. I can't remember that far back, but it did continue until some years after the Second World War. The 2010 picture shows the old marketplace not exactly *crowded* with cars, since many locals feel that the charges are too high. Councillors, please take note.

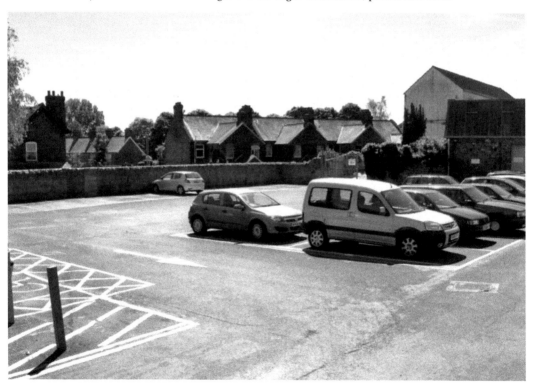

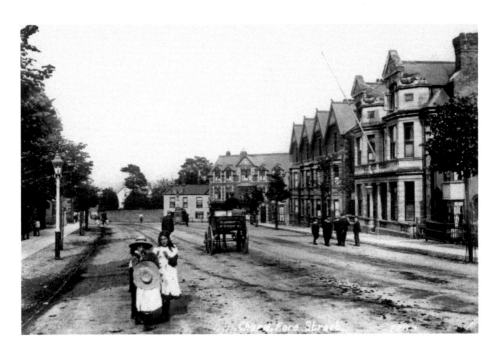

## Fore Street (III)

A fine 1900 shot of the lower end of Fore Street shows the carriers' van moving serenely down the middle and a group of Chard schoolboys having a discussion. The Red House is unchanged, but the adjoining cottage has had a piece sliced off, no doubt to make room for the garage, which stands in place of the brick wall. The wideness of Fore Street is emphasised in the 2010 photograph. Cars are parked on both sides and traffic flows freely, but there are no school boys or girls standing in the road.

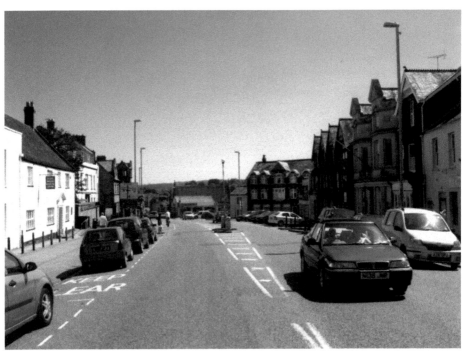

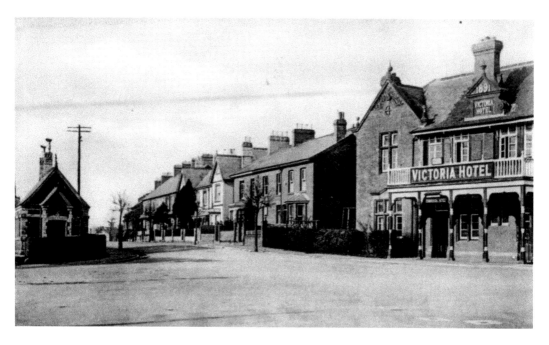

Victoria Hotel

The old Victoria Hotel stands proudly on East Street in around 1900. Across Victoria Avenue can be seen the long-gone weighbridge office. This is perhaps one of the most changed areas of the town. New flats have replaced the hotel; there is also a roundabout and a new road.

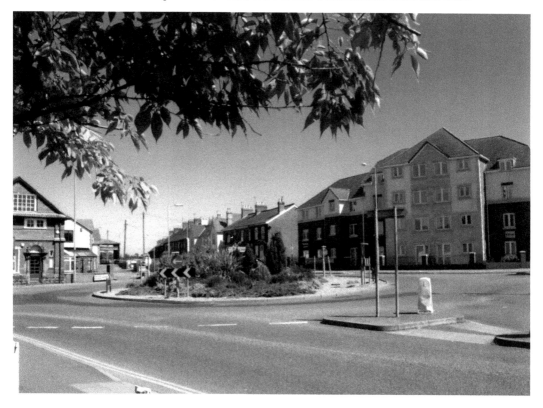

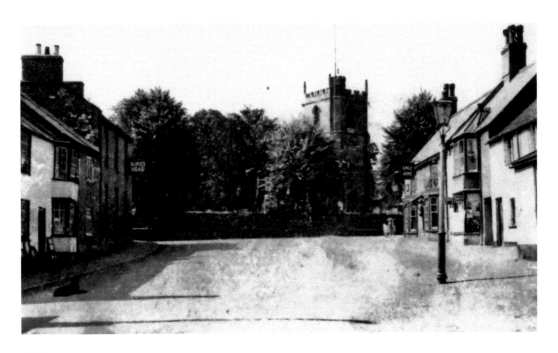

Old Town

St Mary's church tower is prominent at the top end of Old Town. The King's Head is still going strong; the long-closed King's Arms on the opposite corner has now been replaced by a block of flats. Long gone also are Miss Batstone's little sweet and grocery shop, adjoining the King's Arms, and William's, next to the King's Head, which in my younger days was open quite late at night for the sale of fish and chips.

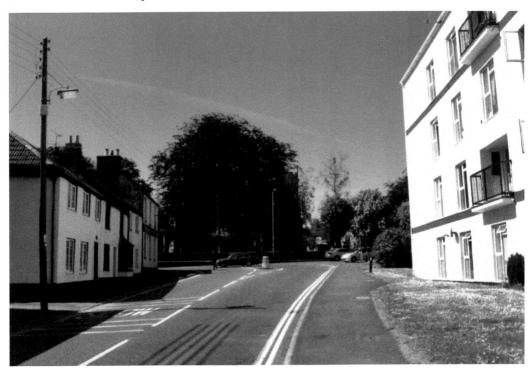

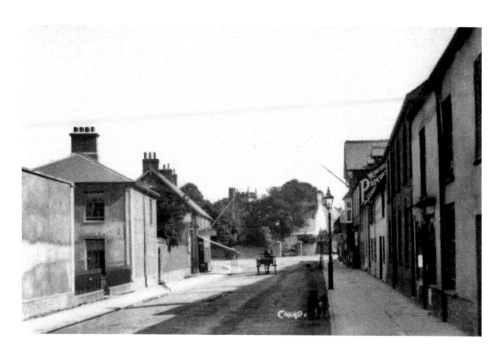

## Holyrood Street (IV)

There are just three dogs and a horse and trap in evidence on an early summer's day at the church end of Holyrood Street. By 2010 the church tower is obscured by trees and the gas lamp has gone. The solicitors' offices are shining white. The frontage of the shops and houses opposite is almost unchanged.

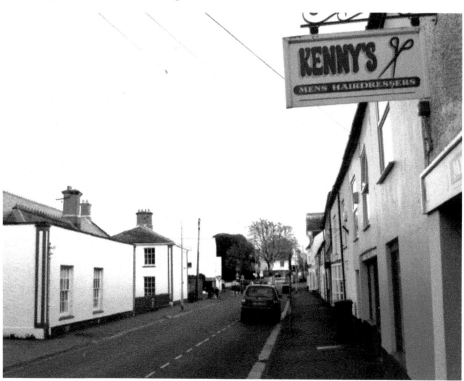

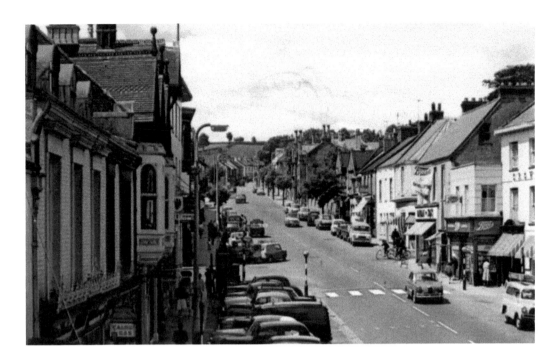

## Fore Street (IV)

From the 1960s to 2010, Fore Street has looked much the same, but there are many changes on both sides of the street. The renowned Crown Hotel can just be glimpsed next to Boots, with stalwarts such as Halses Ironmongers, Parhams & Sons and Harrimans all in evidence. Several of these have vanished and the street has a less busy look in 2010, although the shop fronts have not changed much.

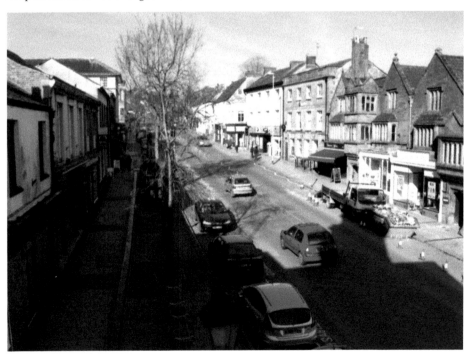

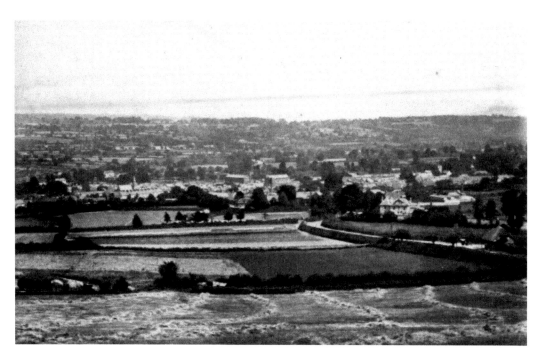

## Snowden Hill

In 1930 Snowden Hill climbed steeply out of Chard on the road to Honiton, and gave a clear view over the growing town. Some eighty years later, the many trees that have grown with the town obscure much of the open view.

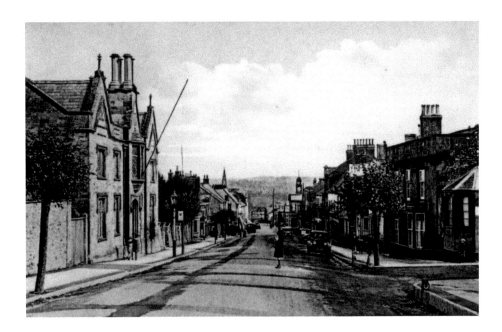

### The High Street (II)

Photographed from the same spot in around 1930 and in 2010, the lower end of the High Street has altered little in eighty years. Harvey's Homes – once a hospital for the poor, now residential flats – and the gatehouse to the Mitchell Toms brewery still stand opposite each other. Sadly, the brewery brews no longer and is now the site of flats for the elderly. Note the gas lamp and the crossroads sign in the early photograph. In both shots, Windwhistle Hill rises in the distance. The A30 road climbs up to Crewkerne and beyond.

## Bath Street

Photographed by the legendary Dave Wheadon in around 1960, Bath Street will be remembered by many locals of senior vintage. Note the stream running down the right-hand side, with the stone 'bridges' in position. This fine old row was demolished in around 1966, the stream was covered over and a new car park was built. An improvement? Maybe, but not visually.

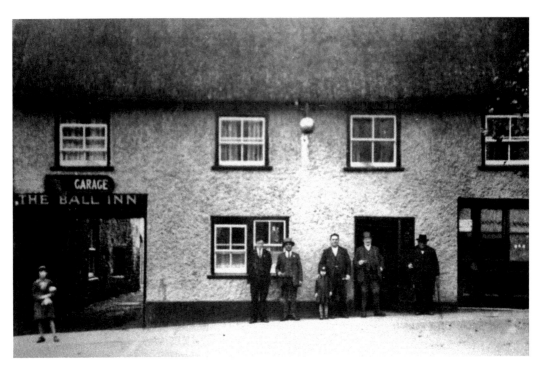

**Ball Inn**

The splendid old Ball Inn, vandalised by planners during the 1970s along with other features of Chard town, was replaced by a concrete monstrosity occupied for some years by Woolworths and today by Store Twenty-One.

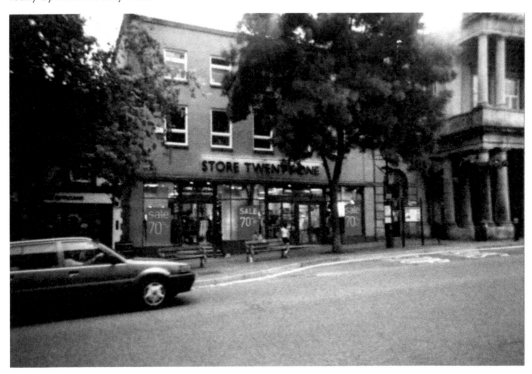

**Forton Road**

This road, leading out of town to Winsham, Crewkerne and beyond, has remained almost unchanged for some eighty years. It is seen in the top picture as it has looked for so long and in the autumn of 2009 as it will probably never look again – with a mass of Tour of Britain cyclists about to enter town. Large crowds turned out to see the riders and to marvel at the organisation that got them along their route so quickly.

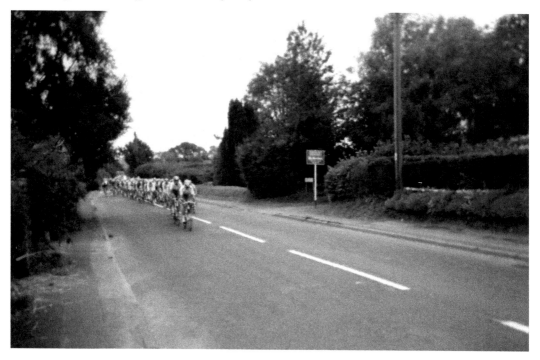

**Holyoake Road**
This fine row of late Victorian houses off Mill Lane became a victim of the town planners in the early 1970s. On the right of the top picture is the start of the new development and to the left are the remains of the renowned Sid Rowley's garage. More housing was created so perhaps the end justified the means.

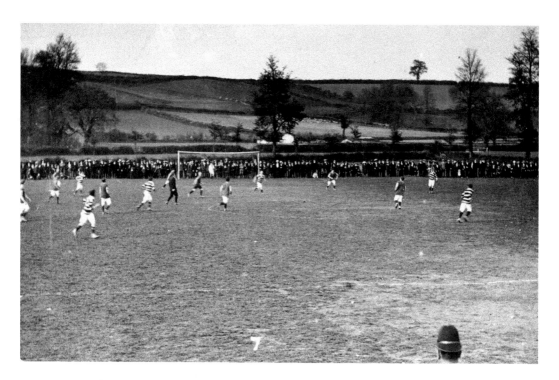

**Bonfire Close**

A hundred years ago the games at Bonfire Close attracted crowds of up to 2,000 and this match was no exception. Note the police presence in the foreground – though how one man would have coped with a riot is questionable. Bonfire Close has for years been a housing estate, but some games were played on this ground in the late forties. Chard had many more football pitches prior to the Second World War, despite the population being less than half of what it is now. Councillors, please take note.

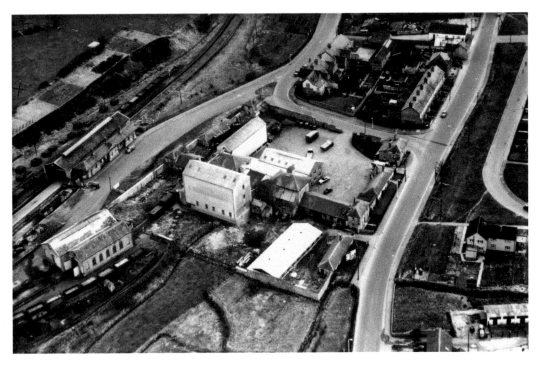

### B. G. Wyatt Ltd

The importance of B. G. Wyatt, supplier of animal feeds, can be judged by the size of its works in the 1950s. Chard Central station is at the top left of the picture and Wyatt's had its own siding, shown bottom left with its line of wagons. The dramatic change to housing and warehouse use is vividly shown in the 2010 photograph.

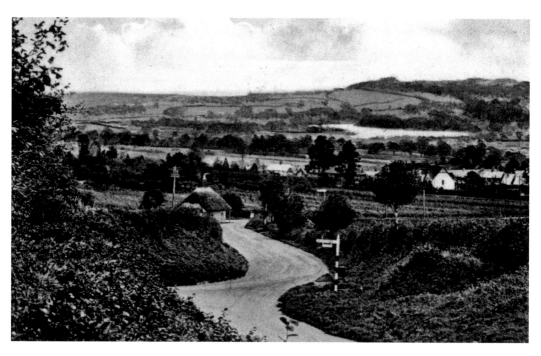

### Chard

The town is seen from Snowden Hill in around 1920 with the reservoir prominent. Below is a distant view of Chard from the opposite Windwhistle Hill on the road to Crewkerne. Both these high places become difficult to negotiate in winter and over the years Windwhistle has had more than its share of fatal accidents.

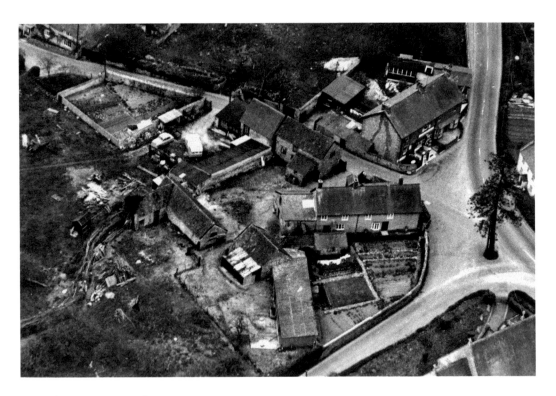

**Parrocks Farm, Tatworth**
The Jubilee Tree is prominent and Wellington's is visible on the main A358 from Chard to Axminster in 1962. Up to the 1960s, Tatworth, Perry Street and South Chard boasted around a dozen shops but today only three remain. In the bottom right-hand corner, part of St John's church can be seen and in the new photograph the road has been realigned.

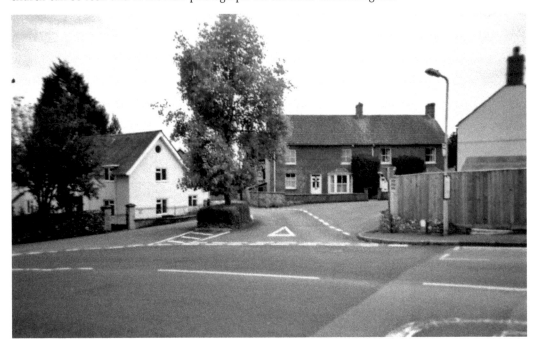

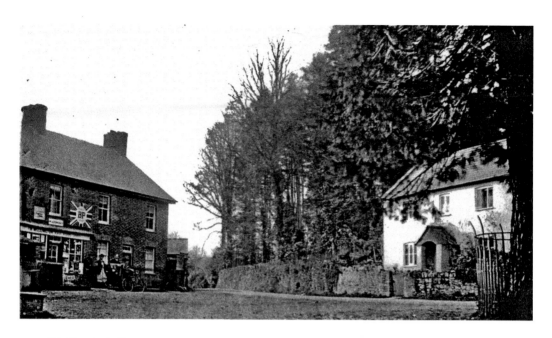

### Wellington's Stores

In this close-up of Wellington's in 1929 the main road runs between the shop and the white house opposite. The petrol pumps have not yet appeared. Today the A358 runs behind the white house; the stores are now a rather grand private dwelling. The old tree was removed in around 1969/70 for road improvements, an act that caused much controversy. As the current picture shows, a tree is again flourishing in much the same spot.

## Tatworth Street

The street is actually in Tatworth, not South Chard, as this 1920s postcard suggests. It is now lined with houses, but the biggest change occurred with the removal of part of the old house on the corner. It is one of the village's oldest dwellings, and now looks very smart, in 2010.

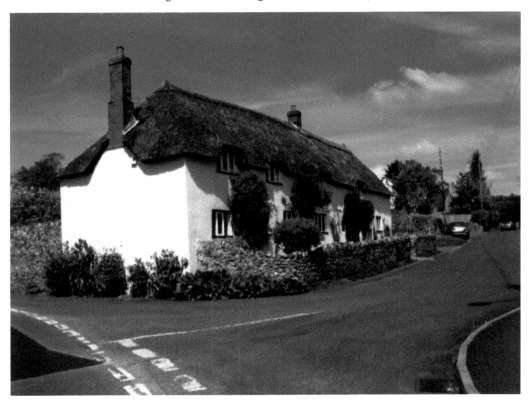

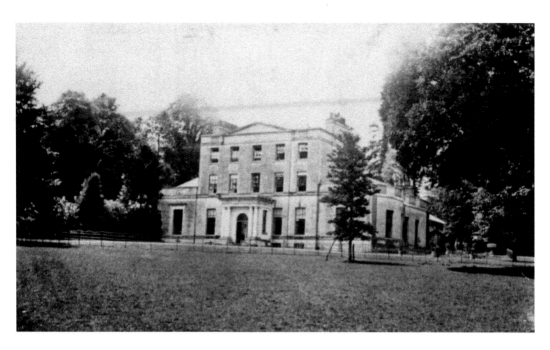

**Parrocks Lodge, Tatworth**
In my day the lodge was home to the formidable Sister Ethel and a small collection of nuns but in 1901, the date of this picture, the Langdon family – nine of them, none of whom married – held sway. In the 1960s the top storey was removed and the house was converted into flats.

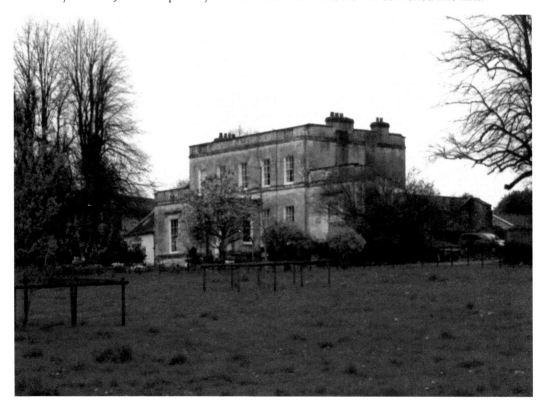

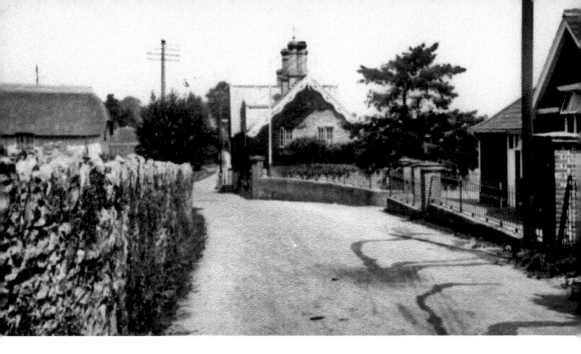

## Tatworth School

Although in South Chard, the premises have always been known as Tatworth School, i.e. the place where I received my early education. The 1930s picture shows the infant school, unchanged in 2010, but the 'big school' further down the road has been totally demolished and replaced with a fine modern building. Gone are the days of the three Rs and the cane, but do the children learn more? I think not.

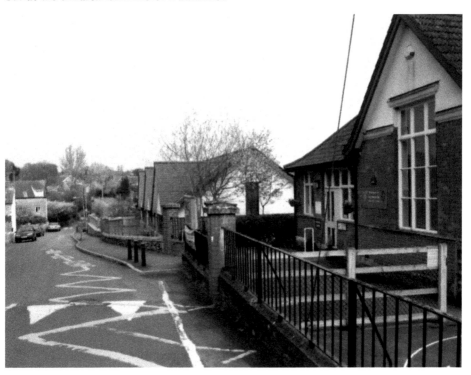

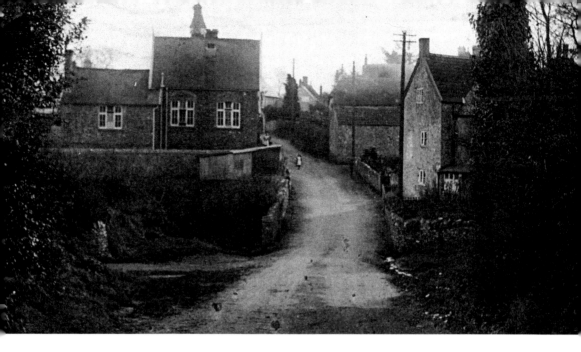

## Tatworth
The old Tatworth School, now replaced with a modern building, is on the left of the picture; 'Jaco' Parris' cottage is opposite. Just across the road from the school was the domain of 'Baker Barges', from where he and his wife dispensed crusty bread, delicious doughnuts and other goodies – much prized by us school children, who would rush across whenever we had a few pence to spare, which was not too often in the 1940s.

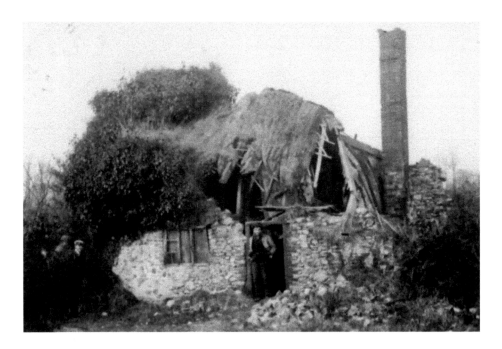

## Moses Coombes

Here standing proudly in the doorway of his 'castle' in the early 1900s, Old Moses was the man to call on for hedging and ditching, two crafts that have almost died out with farmers today. Ditches are left choked, leading to much flooding in rainy spells, and many glorious hedges are shorn too low for wildlife to enjoy. Moses Coombes was a real Tatworth character of the type not seen today. In the recent picture his home is long gone, replaced by modern housing.

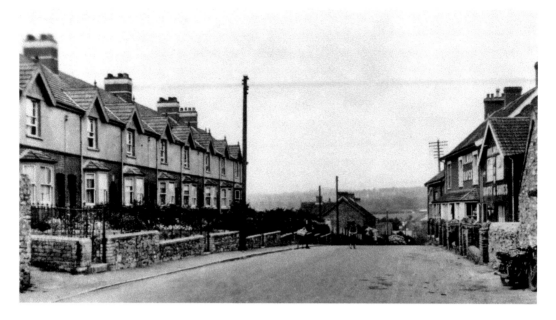

## Dyke Hill

Perry Street, South Chard and Tatworth are actually three separate parts of one large village and the boundaries have always been hazy. Dyke Hill is part of Perry Street, so the caption 'South Chard' on the older shot is wrong. Most of the former factory houses are now privately owned and the 'new' council houses can be seen on the left, down the hill. The shop on the right is still a store with a post office added. Like Holmans, it still sells a vast array of goods.

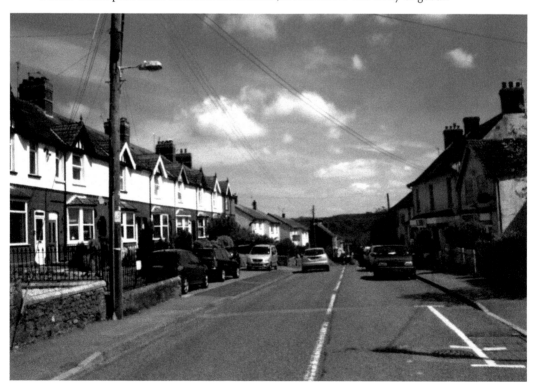

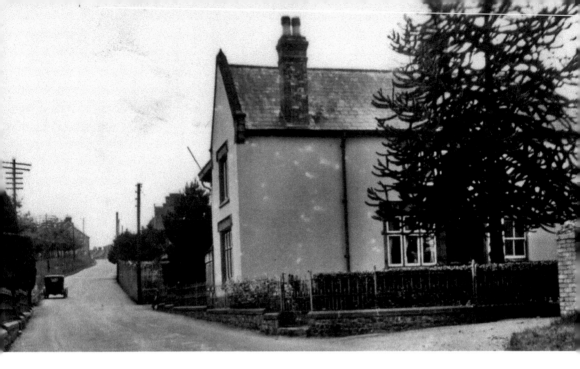

**Perry Street House**
Home of the Small family for many years, Perry Street House has changed little since the 1920s.
Dyke Hill climbs towards Axminster.

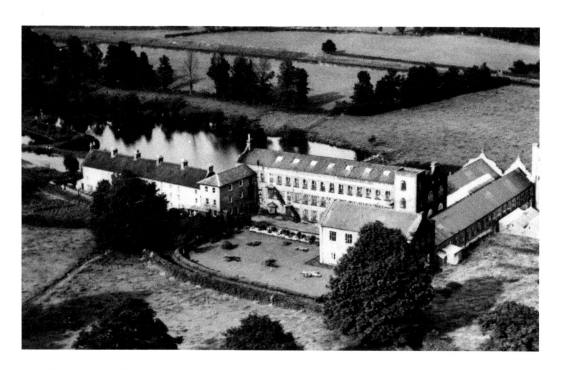

## Perry Street Works

This has been the other big employer in the Tatworth area between 1930 and 2010. Once driven by a large waterwheel, the big pond is now gone and the factory produces mosquito and other nets. It has fewer employees than in the 1930s and '40s, and the production line is more modern.

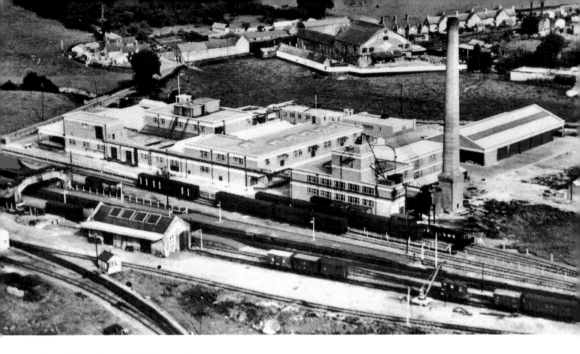

## Chard Junction 'Milk Factory'

The grand 'milk factory' of sixty years ago has been replaced by an unattractive collection of buildings and towers. Now employing far fewer people than in its glory days, the factory still has its reputation for quality products and is an important part of the area's economy.

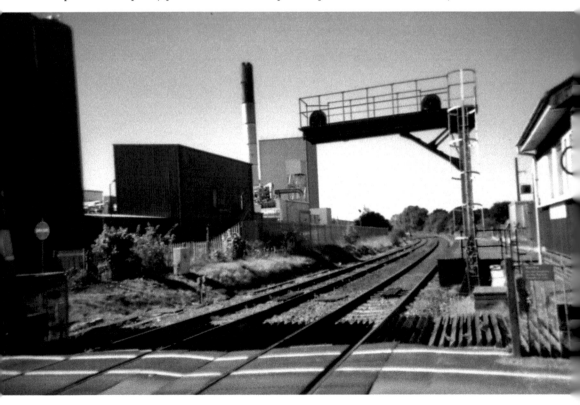

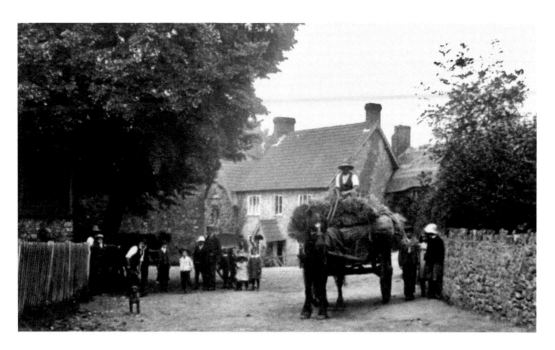

Chardstock

This is the village I was born in, but not quite as early in the twentieth century as this fine shot of the blacksmith's shop in around 1910. Mr. Bonfield, the smith, is busy shoeing a horse. Note the street lamp behind the onlookers – Chardstock was one of the first villages in the country to have street lighting. The present-day scene shows that the blacksmith has gone, likewise the Five Bells pub, which stood next to the George. One of the oldest pubs in Devon, the George is still a popular hostelry.

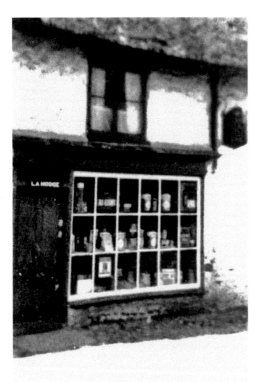

## Strongs

Run for many years by Mrs Annie Hodge, the shop finally closed in 1978. Mrs Hodge was at that time considered to be the oldest shopkeeper in the country; she was well into her nineties when she retired. For many years she supplied Chardstock Cricket Club with teas and any unused items were taken back and put into stock. The house, known as Strongs, fell into disrepair but has since been restored by family members. Staff of the American branch of Strongs have visited the restored premises.

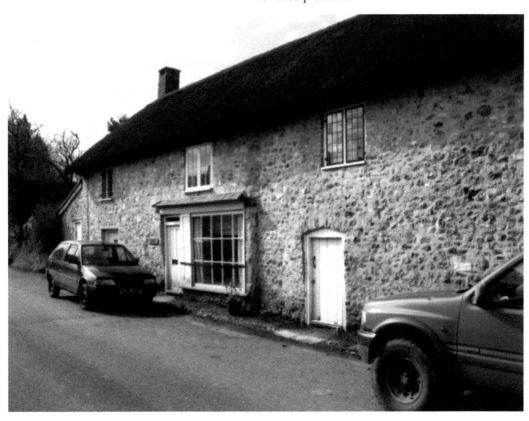

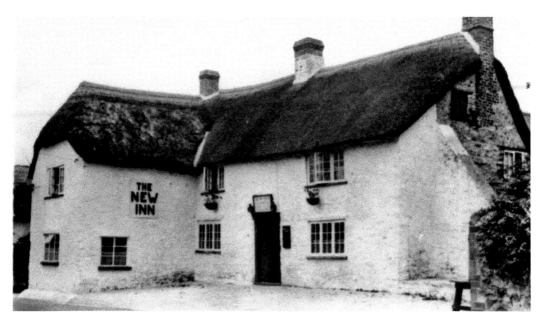

The New Inn

Another of Chardstock's very old buildings, the New Inn dates from the fifteenth century and was a cider and beer house for around a hundred years. It closed in the 1950s. After a decade or so as a hotel, it is once again a private dwelling, as in the 2010 picture.

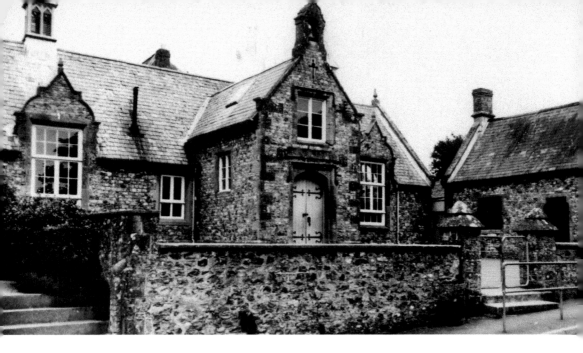

**Chardstock National School**
This school served the village for well over a hundred years until the spanking new school was erected at the other end of the village in 2008.

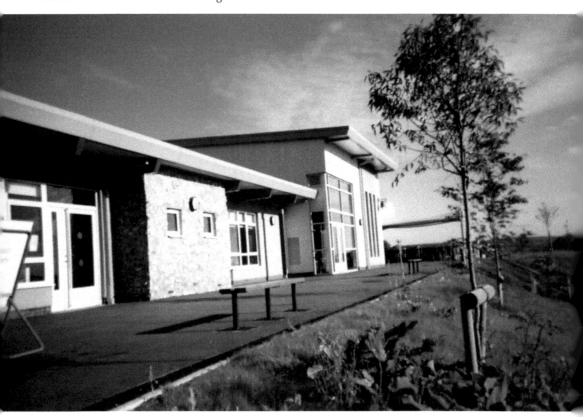

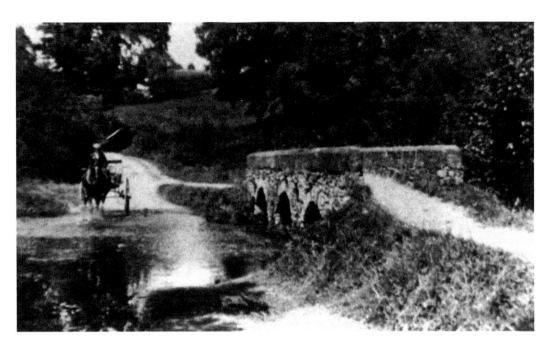

## The Kit

The river flows along the bottom edge of Chardstock and until well into the twentieth century vehicles had to negotiate the fords on their journeys to Holy City and Alston. There were footbridges – as seen in the 1920s photograph of Kitbridge – and the bottom of Mill Hill had a similar foot or packhorse bridge. The Kit had to be forded at Kitbridge until the 1950s; both crossings finally added a road bridge.

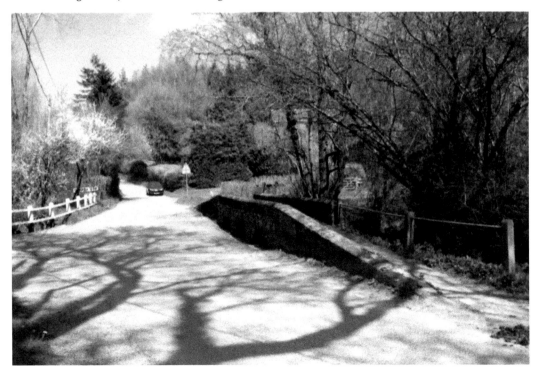

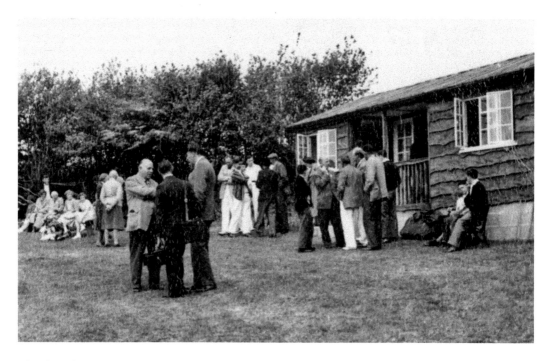

## Chardstock Cricket Club

Two pictures tell the same story some fifty years apart – the opening of Chardstock Cricket Club's new pavilion in 1956 and 2005. Included in the early photograph are many local worthies, none more famous than local photographer Dave Wheadon, who was still taking shots of the area over fifty years later. The splendid new pavilion has club chairman Edward Eames in full flow prior to the official opening by its president, Sir Neville Marriner CBE.

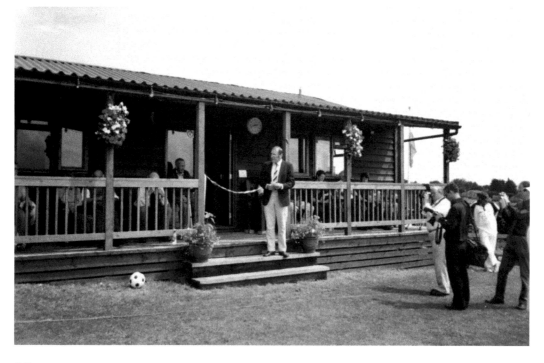

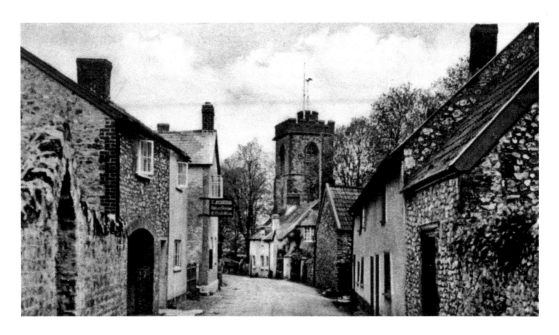

## Church Street, Thorncombe
Always very attractive, Church Street is empty of traffic in the 1920s and in 2010. Note the general store in the early photograph; sadly, like thousands of village shops all over the UK, it is now a private house.

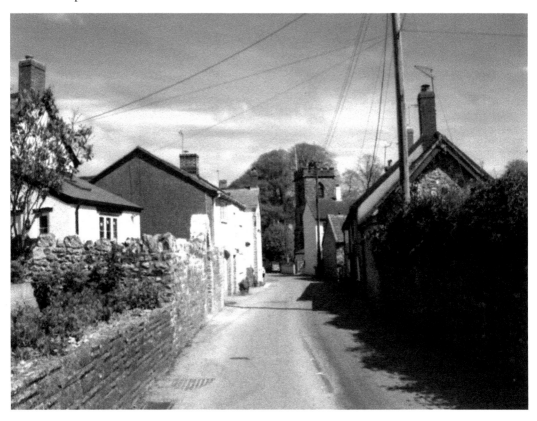

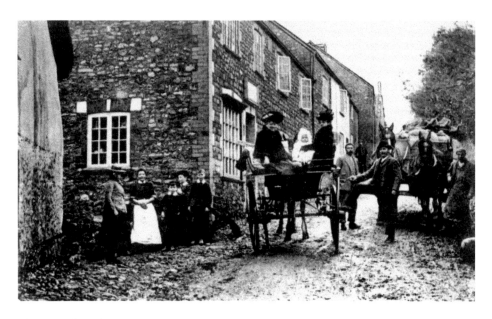

## Thorncombe Bakery

Taken in around 1910, this is a wonderful shot of Thorncombe's bakery. The road is full of traffic. The baker's wife, Mrs Cox, is in the white apron. Thorncombe, like most country villages, was almost self-sufficient in those days and boasted two bakeries for many years, both famous for their crusty bread – I can smell it now – and for cooking the villagers' Sunday lunches. At Chardstock, my home village, baker Miller charged sixpence for this service and I guess all village bakeries were the same. 2010 finds the same building now a private dwelling.

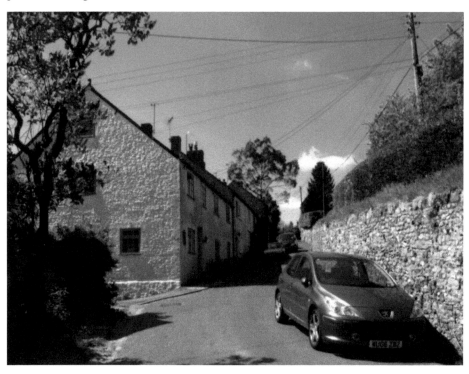

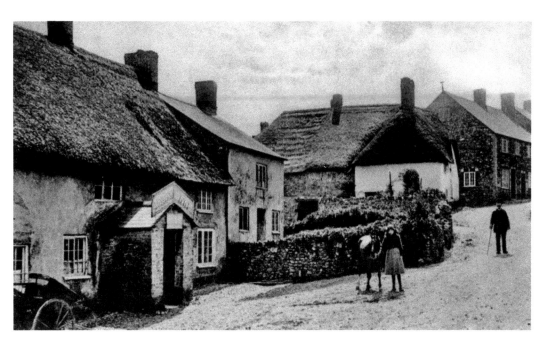

### The Crown Inn

In around 1910, the Crown Inn was one of three pubs in Thorncombe. There were two or three others in the parish. All but the Squirrel at Laymore are now closed. Most villages had several pubs, some of which sold only cider and soft drinks. Today the Crown is an imposing residence.

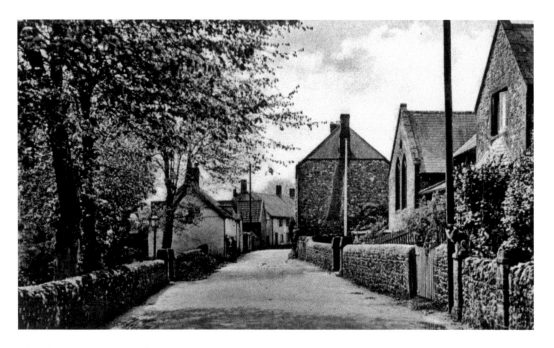

## Chard Street, Thorncombe

There are some eighty years between these two shots. The main difference is the absence of the school. Opened in 1876, it served the village for almost a century until 5 February 1974, when it was destroyed by fire. A new school was opened in September 1977 a few hundred yards from the old site, which is now occupied by private dwellings.

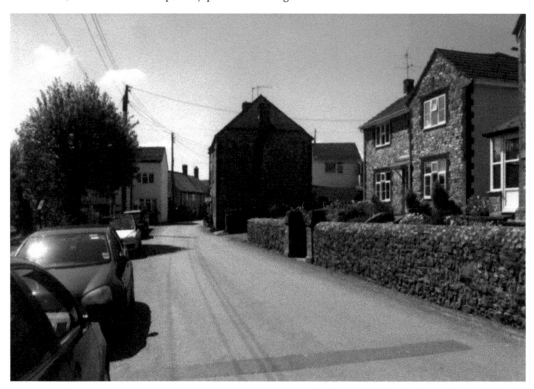

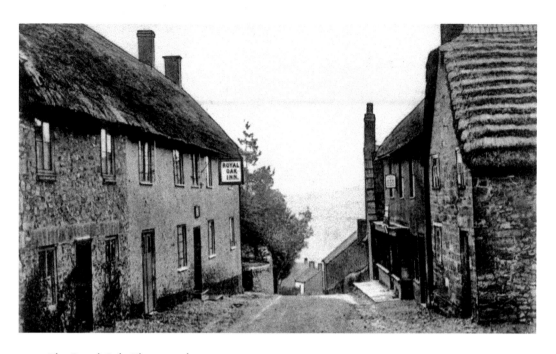

The Royal Oak, Thorncombe
This pub stood directly opposite Bonfield's Stores, for many years the village's main shop. Both are now closed and have reverted to private accommodation. The thatched roofs have been replaced by safer slates and tiles.

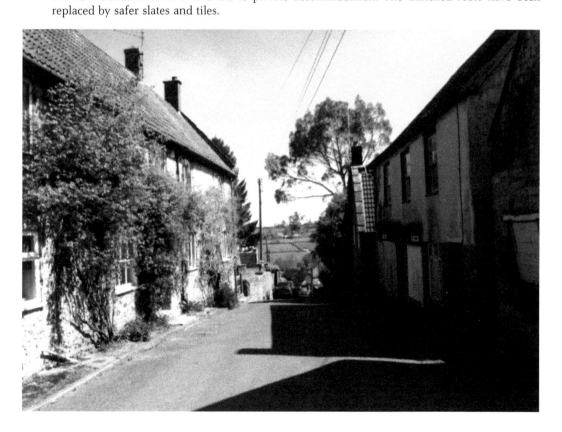

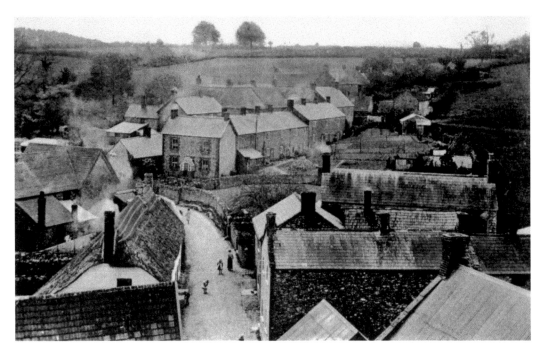

## Thorncombe

There are around ninety years between these two great shots of Thorncombe from the church tower. Photographer Jeff Farley spent his early days in Diamond Jubilee Cottage, more prominent in the early photograph but still much in evidence today. Jeff points out that he was not around when the first photograph was taken.

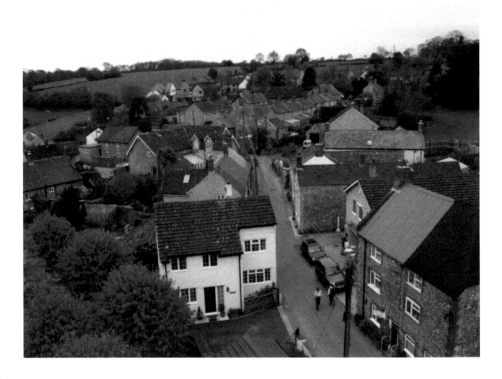

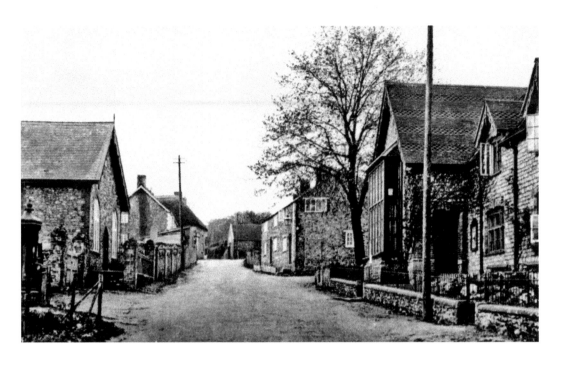

### Thorncombe Chapel
Completed in 1881, the chapel is still a prominent feature of the High Street. The old village hall stood opposite for many years, but with the erection of the new hall a few hundred yards away it has now become an imposing private residence.

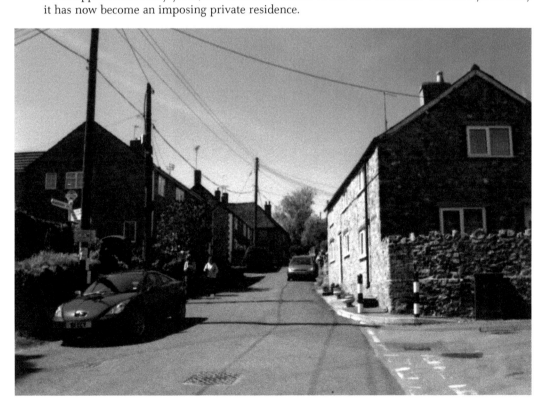

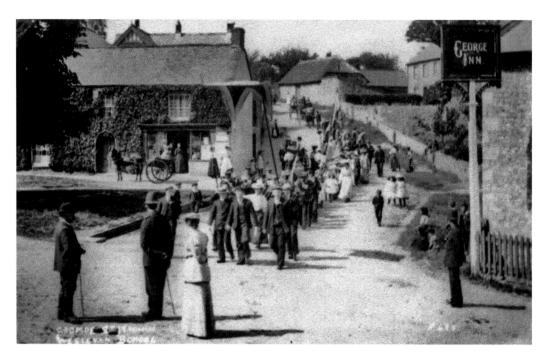

## Combe St Nicholas

In 1908, the centre of Combe St Nicholas hosted a parade of some importance, judging by the two policemen in attendance. The shop and post office can be seen in the up-to-date photograph, but the good old George Inn on the corner is long gone and is now a private residence.

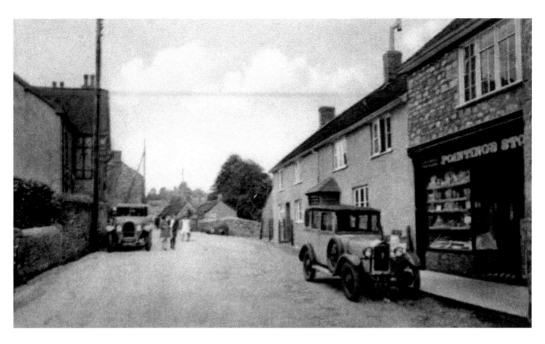

## The High Street, Combe St Nicholas

Another of the village's many shops, Pontings, is visible on the right. The car in front of it features in many local street scenes and was probably owned by the photographer. The shop in the 1925 photograph is gone today but the Green Dragon pub and the school beyond are still very much in evidence.

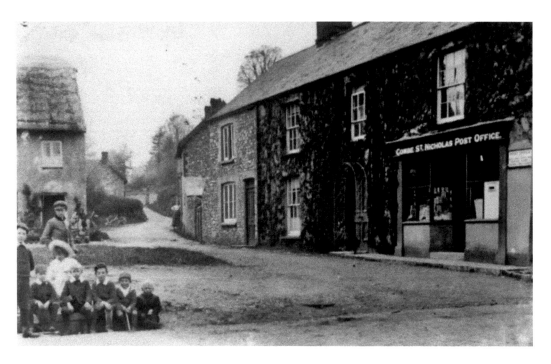

## Combe St Nicholas Post Office

Two scenes separated by over a hundred years show the post office in the same spot on the village green. Before the First World War there were at least three other shops in the village centre but the post office now reigns supreme, along with a general store near the Old George Inn.

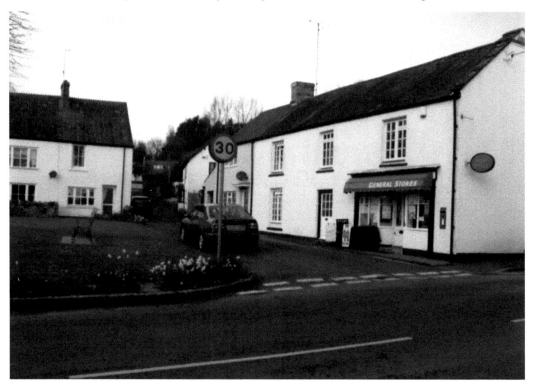

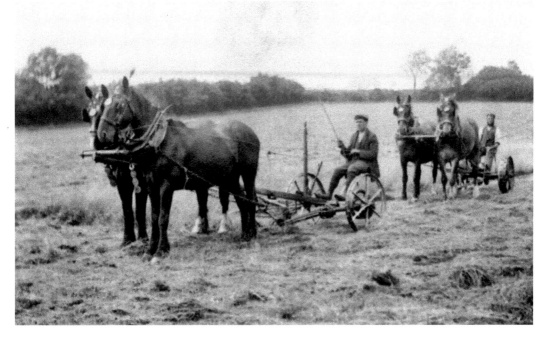

**Combe St Nicholas Football Club**

In a charming scene from around 1900, two teams of horses are working in the hayfield, which over a hundred years later is neatly cut and maintained by Combe St Nicholas Football Club. The impressive clubhouse and dressing rooms offer a perfect view of the well-kept playing area.

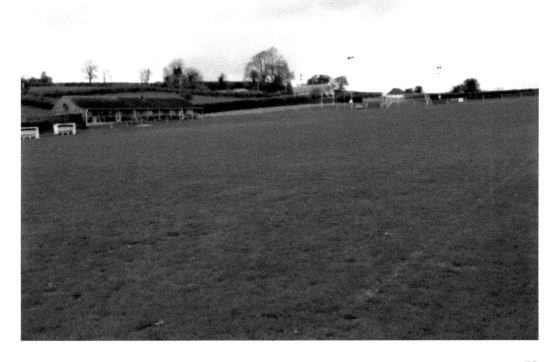

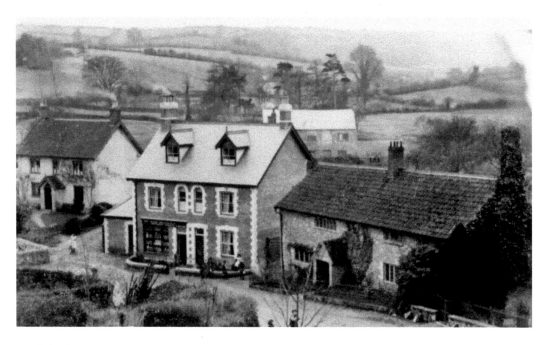

**Wadeford Co-op**

The Co-operative store closed in the 1960s and became a private residence. On the right is the old Owsley's Bakehouse and behind that the powerloom cloth mill, both private houses for many years. The scene has hardly changed over the past fifty years, except for the vanished Co-operative shop window.

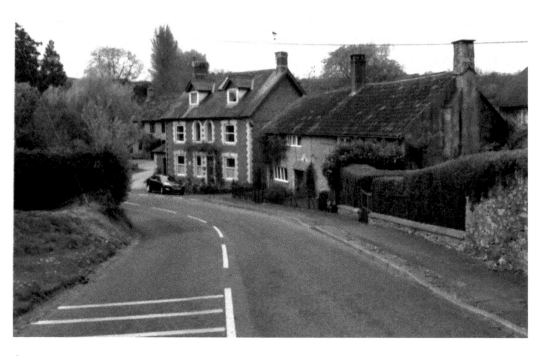

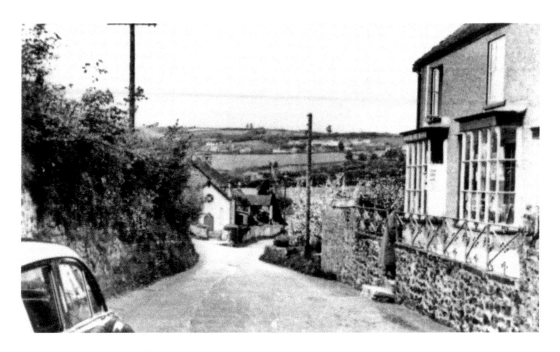

### Wadeford Post Office

A few hundred yards from the old Co-op stood the Wadeford Post Office stores, which closed a few years after its main rival. It has been superbly renovated and is now a fine private house. In the distance is the old Wadeford Chapel, in use in the older photograph but now also a private residence.

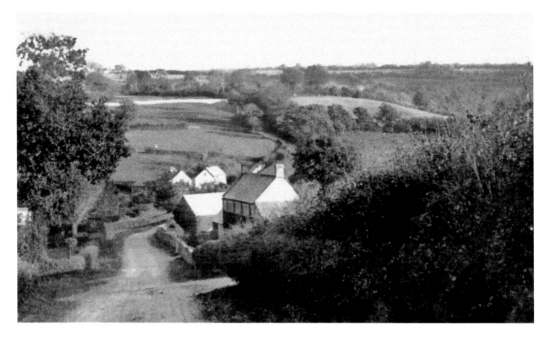

## Bishopswood (I)

On the opposite side of the valley from Buckland, Bishopswood is also devoid of shops, but the Candlelight Inn, once the New Inn, is still going strong as these photographs from around 1910 and from 2010 demonstrate. In the 1910 shot, the butcher's slaughterhouse can be seen directly opposite the pub.

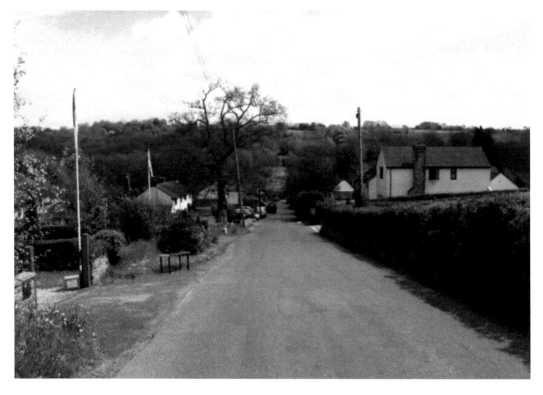

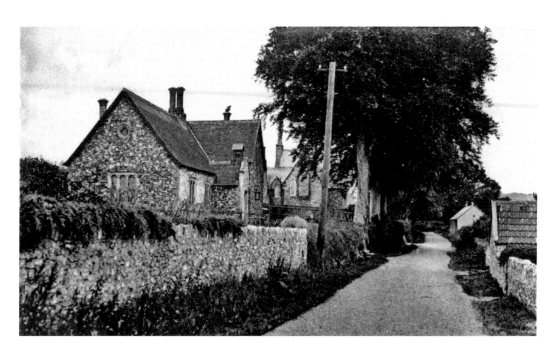

## Bishopswood Village Hall

Opposite the Mission Church in around 1925 was the old village hall, replaced a few years ago by a splendid new building on the same spot. Bishopswood once had three shops with well-known cobbler Alfie 'the Tack' Vincent keeping the villagers well shod. Opposite the old hall was Bishopswood Cricket Club's ground, but the club is now part of Buckland Cricket Club.

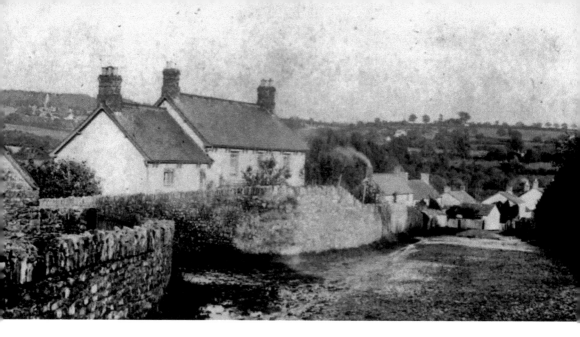

**Bishopswood (II)**

This photograph, taken in around 1890, shows the then untarred road at the top end of the village, with Buckland church visible across the valley. Many of the houses are still standing today. 'They don't build 'em like that anymore.'

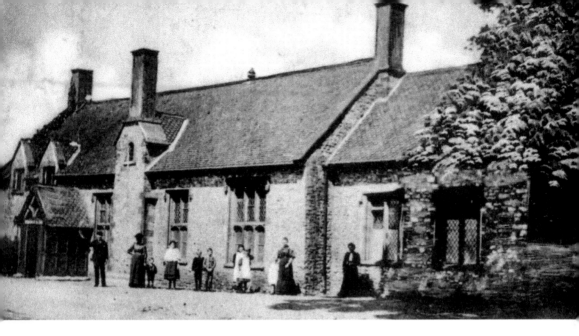

## Buckland St Mary School
Not too much has altered since around 1900, except for the smart new gateway and the cars in the playground. It is still a Church of England school, as are many West Country village primaries, even in this modern and somewhat cynical age.

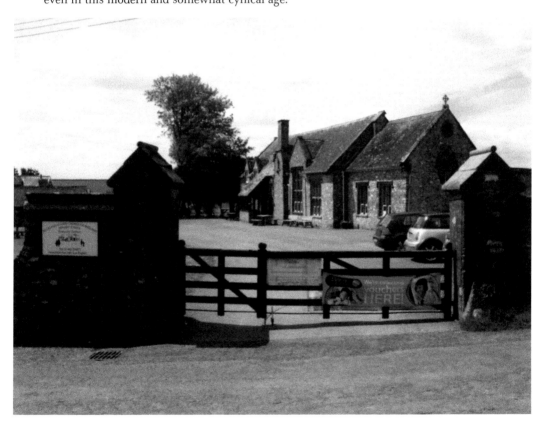

**Buckland St Mary Crossroads**

There are a hundred years between these photographs. A well-known meeting place years ago, it has changed little except for the increased tree growth. Just up the Taunton road is Buckland's splendid new village hall, which can just be seen through the trees behind where the cyclist stood a century earlier before.

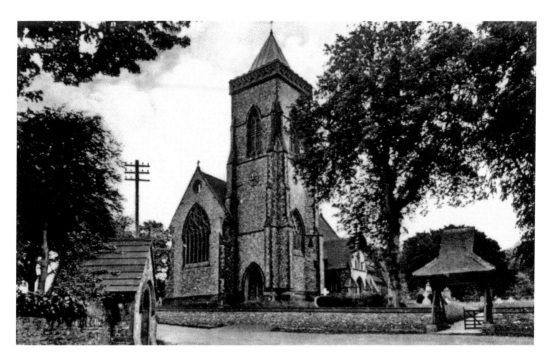

## The Church of St Mary

The imposing church stands in the heart of Buckland St Mary and was little changed in the ninety years between the two photographs, with the exception of the removal of coping from the tower. Buckland is around 700 feet above sea level and the views from the church tower are stunning, and have changed little over many years. Opposite is the village school, still with a healthy pupil roll in 2010.

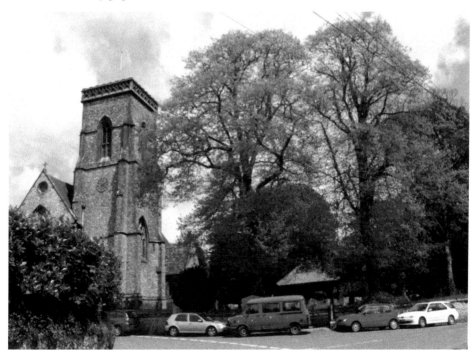

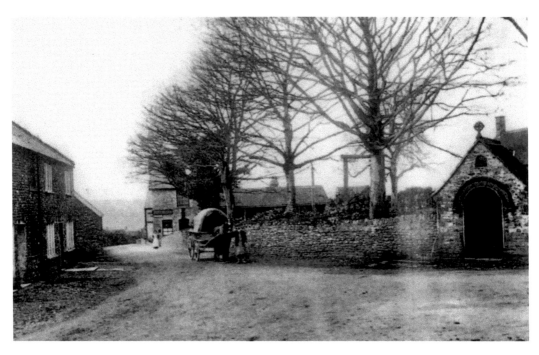

**Buckland St Mary**

Postmarked '1904', this fine shot of Buckland St Mary's village centre shows the local tranter with the post office just behind him. Also visible is the drinking fountain, which still stands outside the school. The post office is long gone; the building is now a private house. The village centre is largely unchanged.

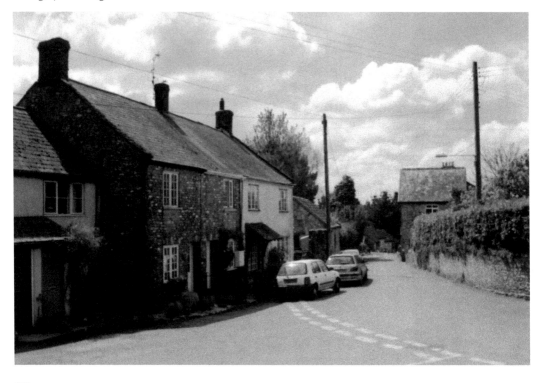

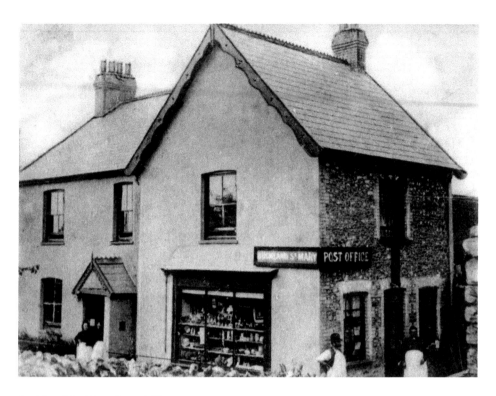

**Buckland St Mary Post Office**

This close-up of the post office shows Mr and Mrs Every on duty. Mr Every was the postmaster for fifty-five years from 1874 to 1929 and the name is still prominent in the village. All that remains is the post box on the wall of the private dwelling.

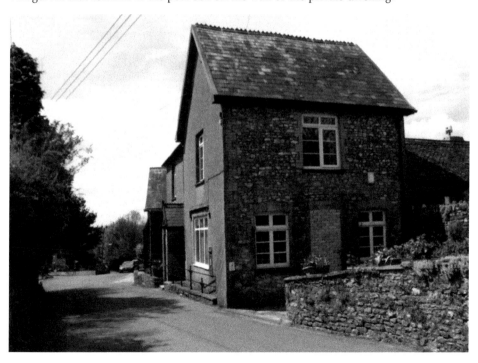

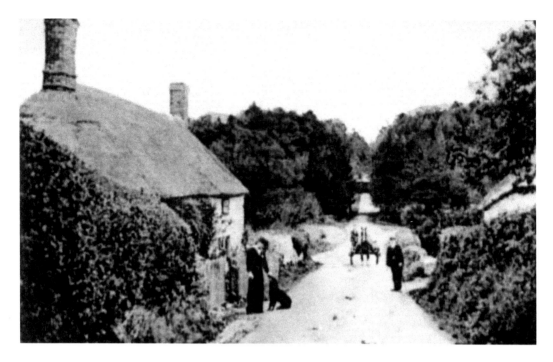

## Forton

This delightful hamlet shows significant change from a century ago. The railway bridge in 1910 remained until the 1960s and when I lived nearby it was all too often taking the tops off high vehicles. The bridge carried the Chard-Chard Junction line and during the war it was part of the 'stop line' that stretched from Seaton to Burnham-on-Sea and included some 215 pillboxes and many anti-tank obstacles, all designed to slow the German advance in the event of invasion.

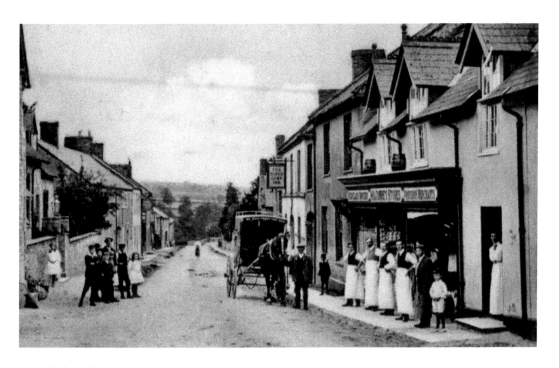

## Holcombes Stores

Situated in Church Street, Winsham, Holcombes was a very busy shop in around 1905, judging by the number of staff and the delivery van. The King's Arms, now closed, was next door and directly opposite was the Jubilee Hall, which is still in use. The store today is operated mainly by volunteers and this early morning shot shows a much less busy street than a century earlier.

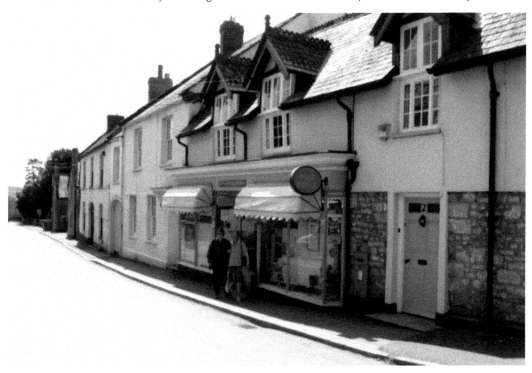

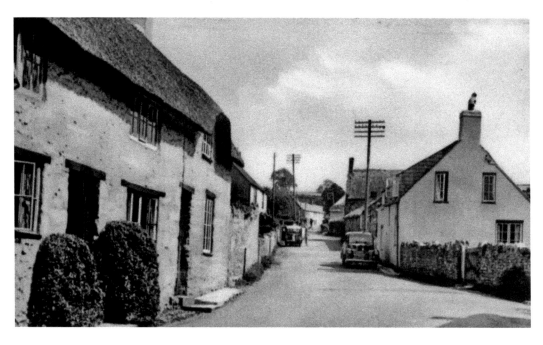

**Fore Street, Winsham**

The street has changed little over the last sixty years. The sun was shining in 1950 and 2010 and the street slumbers just as it has done for well over a century.

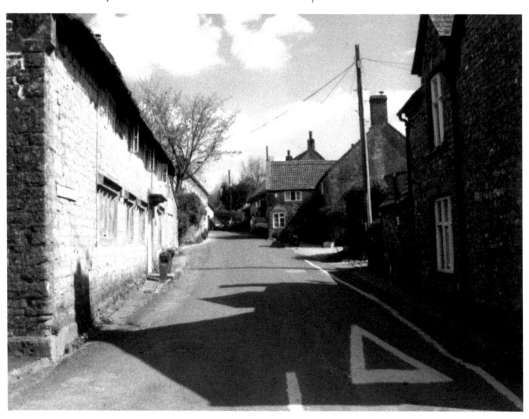

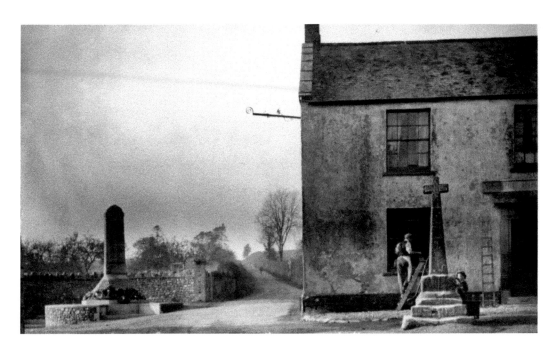

### The George Inn, Winsham

The George Inn was apparently undergoing a face lift in 1923. The new war memorial stands proudly on the corner of the road to Chard. Almost ninety years later it is still standing, now surrounded by housing. The George has become a private residence. The old Village Cross is unchanged.

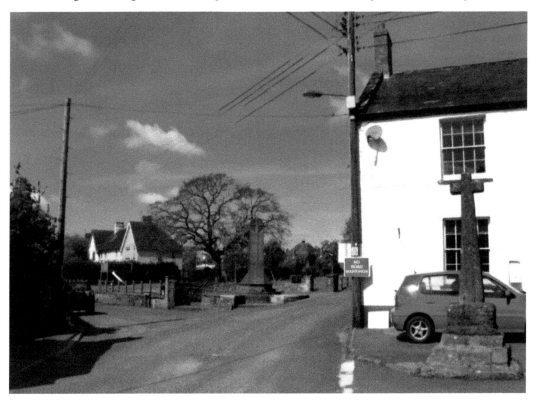

## The Axe

The bridge over the River Axe at Winsham is here photographed in 1908 and 2010. Note the house in the older photograph, long gone today. It was in a very precarious position a century ago, since the Axe has been known to flood to a depth of up to eight feet at this point, and the bridge is still impassable after heavy rain.

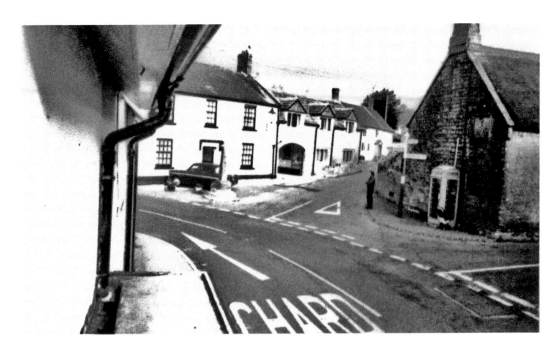

## Winsham

Winsham has changed little since the 1950s. The white house was once the George pub and the road to Chard was more clearly marked over half a century ago. The market cross, the signpost and the telephone box are still in their original positions.

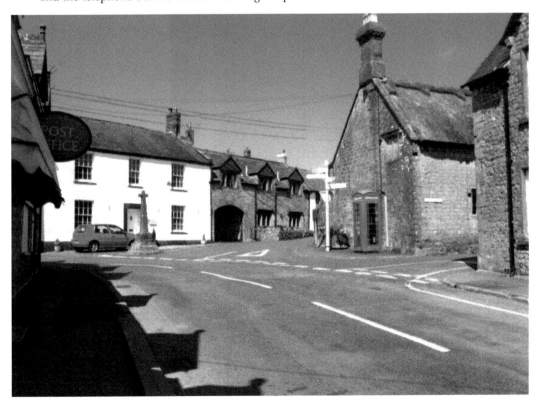

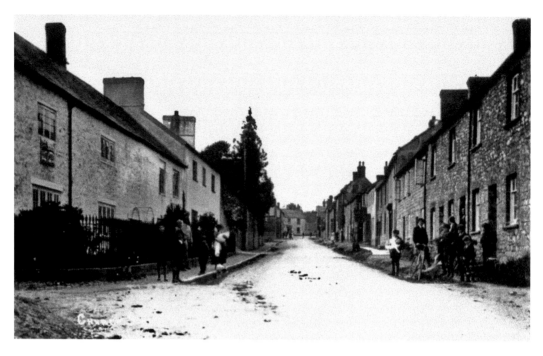

**Church Street, Winsham**

This very early picture is believed to be from around 1890. The houses are the same but today's street is much busier, with buses trundling through on their way to Chard, Crewkerne and beyond.